Aïda Ruilova

The Singles: 1999 – Now

ASPEN **ART** MUSEUM &
CONTEMPORARYARTMUSEUMSTLOUIS

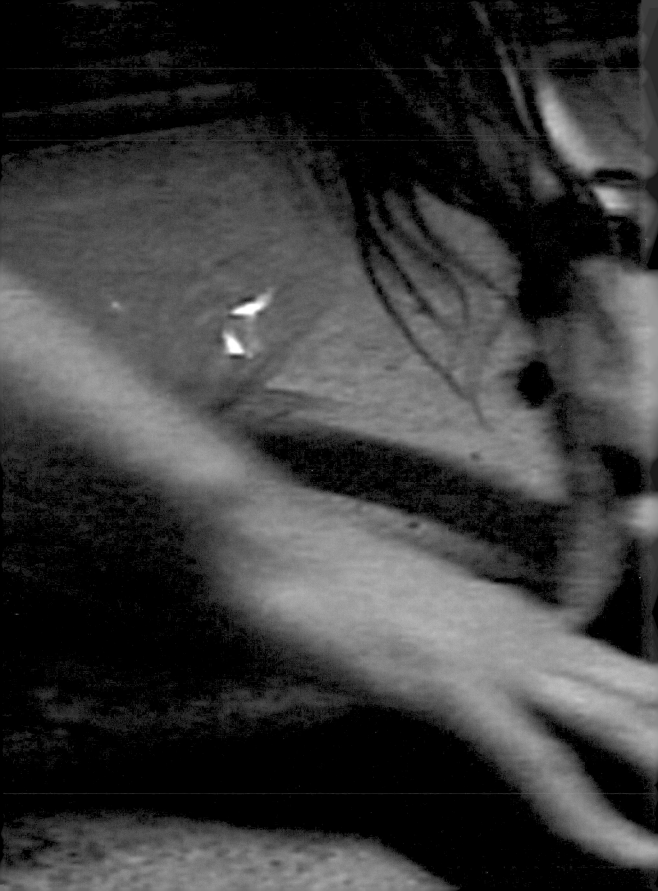

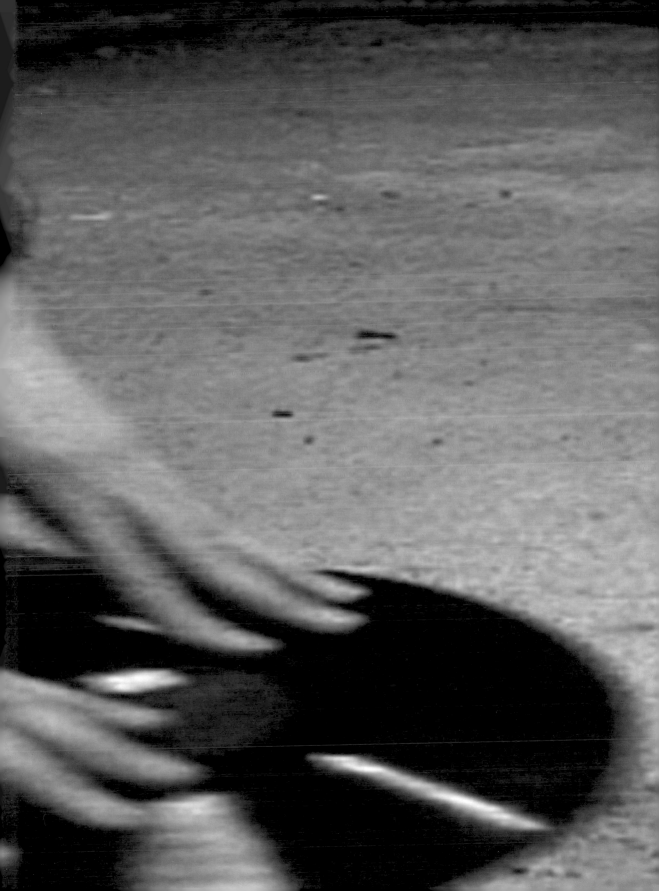

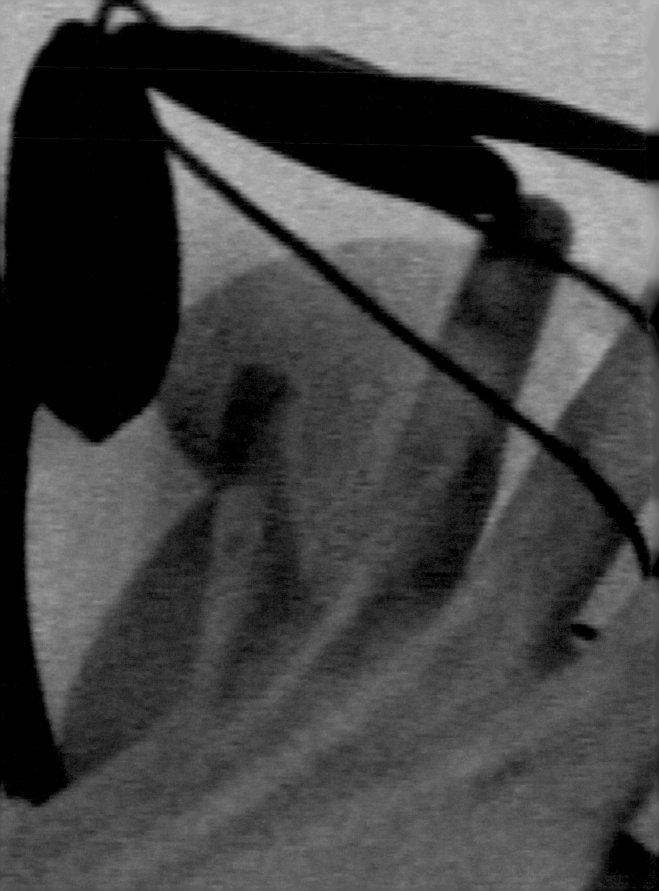

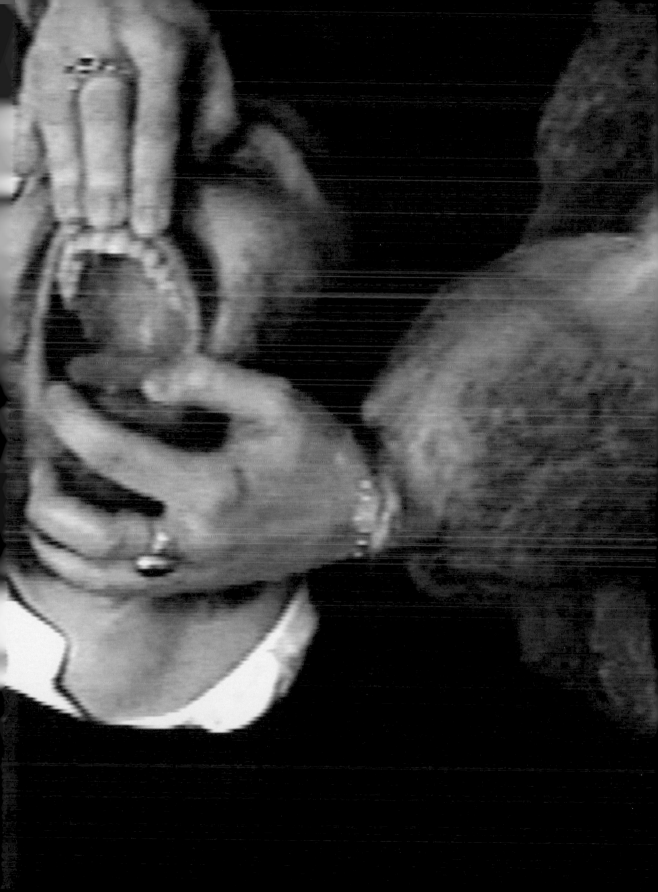

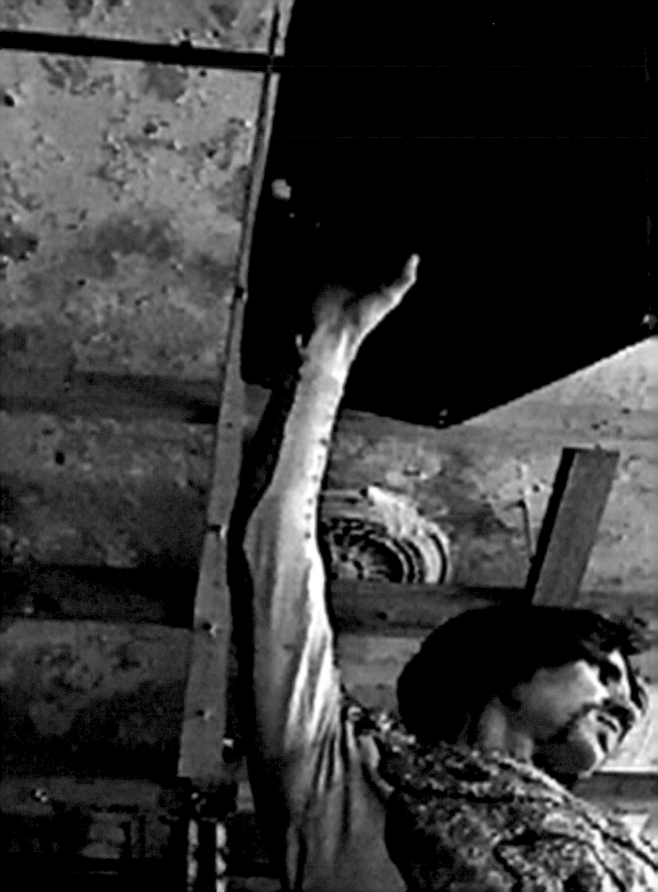

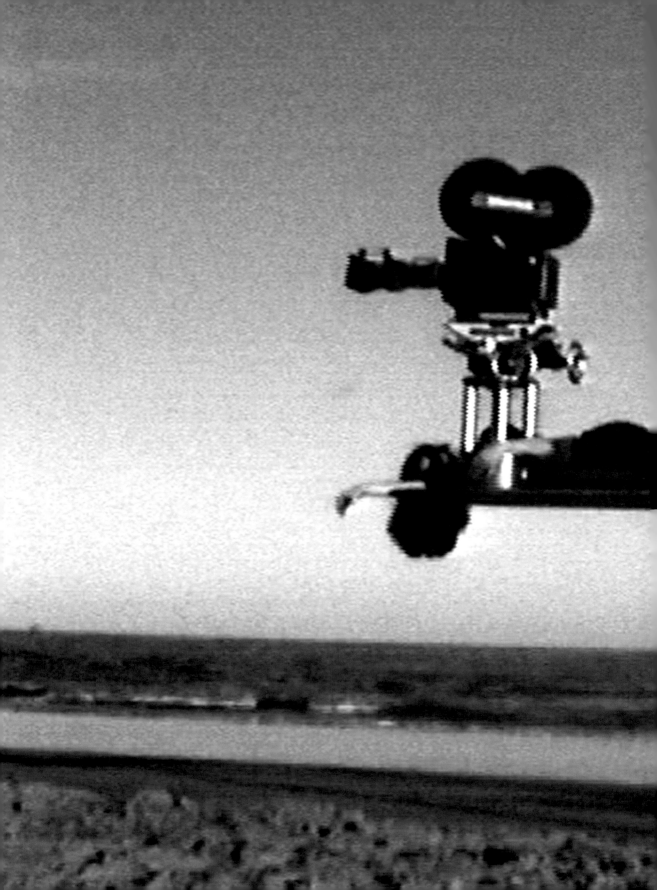

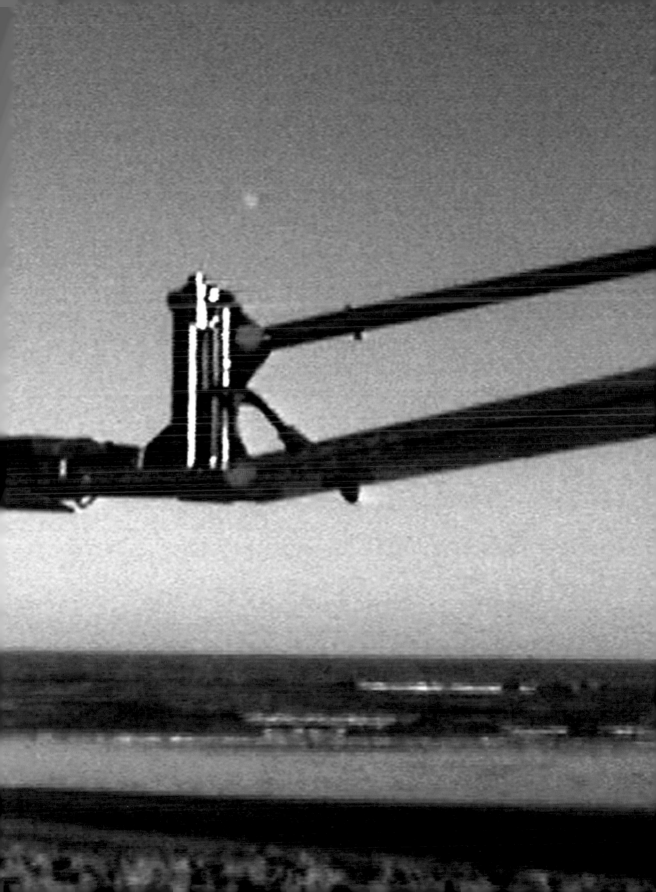

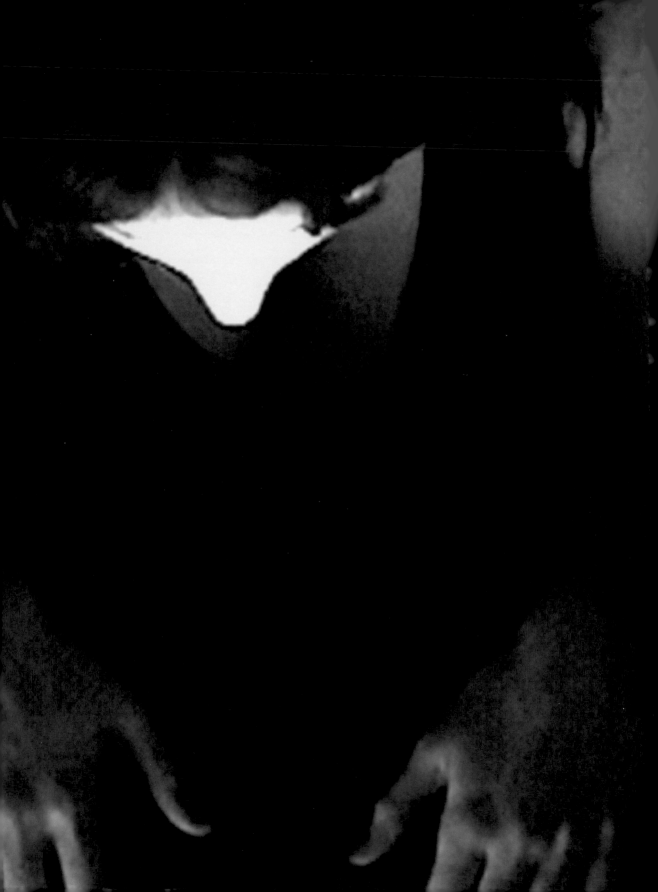

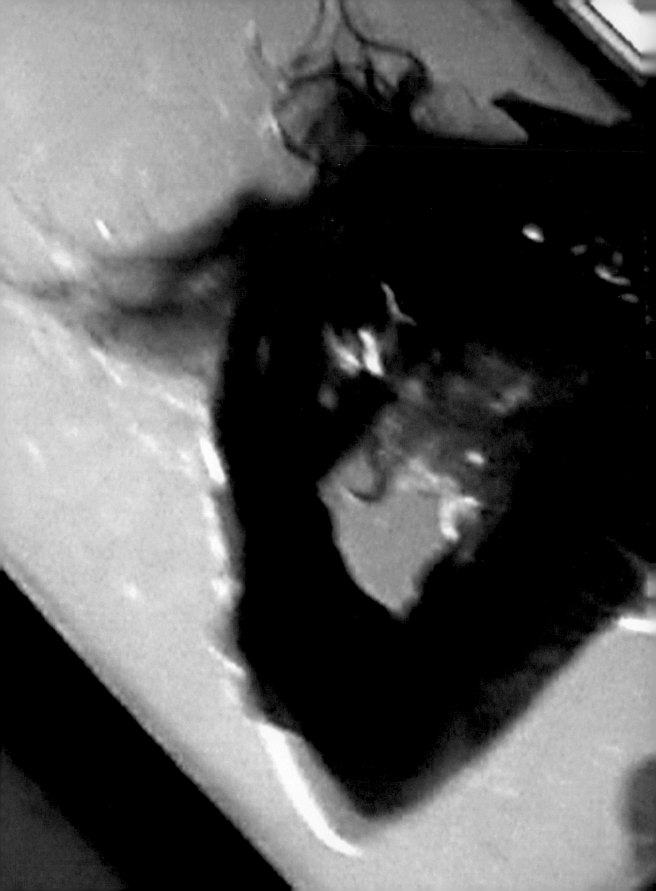

Contents

Acknowledgments

Paul Ha, *Director*
Contemporary Art Museum St. Louis

Heidi Zuckerman Jacobson, *Director and Chief Curator*
Aspen Art Museum

AÏDA RUILOVA: THE SINGLES 1999 – NOW
WAS CONCEIVED JOINTLY BY THE ASPEN
ART MUSEUM AND THE CONTEMPORARY
ART MUSEUM ST. LOUIS. The exhibition and
its accompanying catalog would not have been
possible without the dedicated and generous
support of key individuals, foundations, and private
sponsors, all of whom recognized the importance
of an exhibition of single-channel works by an
artist whose unique vision deserves comprehensive
investigation.

At the Aspen Art Museum, we wish to thank
our colleagues: Visitor Services Assistants Karen
Andrade and Dasa Bausova, Chief Preparator
and Facilities Manager Dale Benson, Campaign
Coordinator Grace Brooks, Membership Assistant
Ellie Closuit, Assistant Director for Finance and
Administration Dara Coder, Curatorial Associate
Nicole Kinsler, Executive Assistant to the Director
Lauren Lively, Education and Public Programs
Manager Morley McBride, Public Relations and
Marketing Manager Jeff Murcko, Graphic Designer
Jared Rippy, Assistant Graphic Designer Rachel
Rippy, Assistant Development Director Christy
Sauer, Development Director John-Paul Schaefer,
Visitor Services Coordinator Dorie Shellenbergar,
Registrar and Exhibitions Manager Pam Taylor,
Assistant Curator Matthew Thompson, Special
Events Assistant Wendy Wilhelm, and Staff
Photographer Karl Wolfgang. We are proud and
honored to work with each and every one of you.

For the Aspen Art Museum presentation of
Aïda Ruilova: The Singles 1999 – Now, we
are especially grateful to the Aspen Art Museum
National Council for its ongoing financial
support of the museum's exhibitions. Substantial
underwriting from Jay and Jill Bernstein helped
make this exhibition possible. Toby Devan
Lewis provided significant support to realize
the completion of this publication. Each can be
numbered among the Aspen Art Museum's most
steadfast and generous supporters.

At the Contemporary Art Museum St. Louis, we
wish to thank the Board of Directors—especially
its Chair, John Ferring, for his perceptive insights
into the art of our time and for his dedication
and commitment to the Contemporary. The
staff at the museum has consistently provided
unparalleled support for all of the projects we have
undertaken, and this one is no exception. We are
indebted to the continued hard work of Director
of Education Kathryn Adamchick, Manager of
Institutional Giving Shannon Bailey, Director of
Public Relations and Marketing Jennifer Gaby,
Manager of Donor Relations and Special Events
Erinn Gavaghan, Deputy Director and Director
of Development Lisa Grove, Program Assistant
Katrina Hallowell, Chief Curator Anthony
Huberman, Facilities Manager Jason Miller,
Projects Assistant Maria Quinlan, Registrar and
Event Operations Manager Cole Root, Education
Assistant Ben Shepard, Exhibitions and Operations
Manager Shane Simmons, Visitor Services and
Retail Coordinator Kiersten Torrez, and Director of
Finance and Administration Mary Walters. We wish
to single out Assistant Curator Laura Fried and
Graphic Designer Bruce Burton for gracing this
project with their talent and energy. Thank you for
making this exhibition and catalog possible.

The St. Louis presentation of the exhibition is
made possible through the generous financial
support of the Whitaker Foundation, William E.
Weiss Foundation, Regional Arts Commission,
Arts and Education Council, Missouri Arts Council,
and members of the Contemporary Art Museum
St. Louis.

We are also grateful to those individuals who have
in numerous ways contributed to and enriched this
project with their support and encouragement.
We extend our gratitude to Augusto Arbizo, Betsy
Brandt, Dwyer Brown, Emily Baldwin Bryan,
Dan Cameron, Silvia Chivaratanond, Wendi
Elmore, Elizabeth Fluke, Genevieve Griffin,
Teneille Haggard, Ray Juaire, Tara Luckett, Leia
McFadden, Nancy Reynolds, Lauren Ross, Barry
Schwabsky, Jill Snyder, and Umberto Umbertino,
each of whom has helped make this exhibition and
publication a reality.

We are particularly indebted to Jeanne Greenberg-
Rohatyn and Fabienne Stephan of Salon 94, New
York, for their help in all aspects of organizing
this exhibition. We also wish to thank Gerald
Zeigerman for his careful and insightful editing of
our book. We extend our heartfelt appreciation to
Guido W. Baudach and Jeanne Greenberg-Rohatyn
for contributing funds for this publication.

Last, we must thank Aïda for the gift of her
immense talent and creativity, which inspired us to
produce this exhibition and catalog.

Introduction

Paul Ha

WHY I ♥ AÏDA RUILOVA'S WORK

I love the fleeting moment. I love being in that moment when a thought begins to flee from the brain and you become aware you are about to lose it, so you chase after it and desperately try to hold on. But inevitably the thought disappears, and you are left like a lost tourist, confused and roving the halls of your mind. Frantically, you try to find the thought, but in the end, you wind up trying to recall what it was you were trying to recall.

For Aïda Ruilova, B movies, especially movies with "Gothic sensibilities," are grist for her mill. It has been noted that her work is influenced by Sergei Eisenstein and Andrei Tarkovsky, and indeed, what she has produced is almost like a child born of their union.* By combining incessant montage—a technique Eisenstein pioneered—with weird references to spirituality and metaphysical themes à la Tarkovsky, she creates a sensibility all her own. A compelling, though obscured, narrative is created, overwhelming the viewer with questions. Unidentified, Ruilova's characters remain ambiguous. They and their acts provoke a stream of questions: Is she the hero? Is he the victim? What are these mysterious acts, and why are these people so caught up in them? What are they searching for? Is there a message?

I am fascinated that Ruilova persists in inserting the structure of music into her work. Her images create visual assaults through loops, patterns, and frenzied cadence. The visual experience is akin to musical syntax. What is initially chaotic and random begins to create an order and rhythm not unlike a song formula. The job of our neurons is to help us recognize patterns, to make sense of our disorder. As we watch Ruilova's work, we are actively developing the skills to understand the videos. As patterns emerge and the hidden order seems within our reach, somehow the understanding suddenly disappears. It is when we become aware that we may be close to finding a pattern that we get lost again. The patterns remain frustrating, hard to pin down. When watching Ruilova's work, we are in a constant state of search. We are in a never-ending corridor of opening and slamming doors. But, during the act of the search, we are also trying to recall what it was we were looking for—like that lost tourist trying to recall what it was he was trying to recall.

*Notable are essays by Silvia Chivaratanond and Barry Schwabsky: Chivaratanond, "Ouverture: Aïda Ruilova," *Flash Art International* 34, no. 219 (July – September, 2001), 114; and Schwabsky, "Aïda Rulova: White Columns," *Artforum* 39, no. 4 (December 2000), 148.

Aïda Ruilova: Tell Me Again

Heidi Zuckerman Jacobson

ART HAS ALWAYS BEEN COMMITTED TO THE SERIOUS SUBJECTS. Initially, art chronicled the basic needs for survival: where to locate food; who belonged to which tribe; how to avoid the perilous pitfalls of daily existence. At the beginning of the twenty first century, in the hands of a generation of artists born in the mid-1970s, art, once again, is focused on life and death. These artists are introducing a revised nineteenth-century concept of the glorification of death. A morbid fascination within today's youth culture is also well entrenched and widely chronicled. Through music, popular magazines, fashion, and movies, the desire to live on or very near the edge emphasizes a prevalent, youthful conception of immortality.

The very idea of an edge enforces the possibility of its being crossed. On August 17, 2007, *The New York Times* headline read, "2006 Suicide Rate for Soldiers Sets a Record for the Army." Ninety-nine soldiers killed themselves that year. At a rate of 17.3 per 100,000, the suicide rate is the highest since the army started counting in 1980.[1] Recently, midlife suicide —as well as female and male tween suicide—has also risen. Why? The evidence is apparently as unclear as "the confusion and mystery at the heart of suicide itself."[2] Perhaps a suicide attempt is intended to test the intrinsic concept of immortality: is death possible or will any attempt to end one's life somehow be mysteriously thwarted? Perhaps they counteract the notion of immortality. if life is so hard, so difficult, then the idea of living forever becomes all the more impossible to bear. Popular culture encourages these notions. As art critic Steven Vincent wrote, "You have to wonder about that aspect of American pop culture that encourages young men and women to glamorize death, worship Satan, embrace suicide as a lifestyle choice, and listen to music fit only for amphetamine freaks."[3]

Aïda Ruilova was born in 1974, in Wheeling, West Virginia, and grew up in Florida, considered at the time the "Death Metal Capital of the World." Music is prominent in her work, as well as in the work of other artists of her generation, not only as soundtrack but as posture, physicality, and association. As youths around the country turn up the volume to drown out authority, responsibility, and fear, a feeling of empowerment and community evolves. Although artists and musicians usually can distinguish art from life, sometimes viewers and listeners have a tougher time. Banks Violette explained his artistic practice as "analyzing an event or phenomenon in a literary or operatic way," a practice he views as counter to "murders related to heavy-metal culture [which] are about an overt theatrical excess that gets literally enacted. When singing figuratively about killing turns into a literal command."[4] But if the artist or musician is compelling, conveying a sense of intimacy and honesty, might it be difficult to tell the difference? Might that, in fact, be the aim of the art product itself, to blur those lines, to stir emotion, to cause an effect? Violette admits, "There's a part of me that almost feels envy for artists who could create something that powerful—although I realize the consequences."[5] In a positive review of the band Sunn O))), critic Jan Tumlir explains,

[1] The Associated Press, "2006 Suicide Rate for Soldiers Sets a Record for the Army," The New York Times, August 17, 2007, A16.

[2] Patricia Cohen, "Midlife Suicide Rises, Puzzling Researchers," The New York Times, February 19, 2008.

[3] Steven Vincent, "Death Becomes Him," Art Review 2, no. 3 (March 2004), 64.

[4] Jan Tumlir, "My Pop," Artforum 43, no. 2 (October 2004), 86.

[5] Vincent, "Death Becomes Him," 65.

"To place oneself at the point of greatest sonic impact is an act of fetal surrender and Nietzschean bravura at once."[6] Lingering at the edge can produce a seductive form of ecstasy that allows a defiance of mortality itself. Death, or at least the idea of it, makes life more alive.

The 2004 Whitney Biennial highlighted the current fascination in art with all things dark, cloaking the exploration under the mantle of "the Gothic." In the text for his exhibition *All the Pretty Corpses*, curator Hamza Walker investigated "mysticism, anger, mourning, horror, aggression, angst, apocalypse." He wrote, "Goth's matriculation into popular culture is also an acknowledgment that the darker inclinations of youth culture have been made permanent."[7] Why did death make a comeback? That same year, the curator of the desperately depressing Carnegie International saw the work as a reaction to post-9/11 times. That is one reasonable explanation; this text explores other possibilities.

Like Ruilova, Amie Dicke and Jay Heikes isolate and repeat a gesture. With an X-acto knife and pen, Dicke works directly on magazine advertisements, transforming the beautiful women represented into "dark phantom traces of their photo-shoot selves."[8] The resulting images recall Goth makeup, dripping blood, and ghoulish physical shells. Dicke overlays violence on a mainstream form of communication, subverting the images of females to convey something far more sinister. Heikes also employs elements of popular culture, telling a joke—the same joke—over and over. The elements of the joke metamorphose into sculptural elements as well as two-dimensional works, continuing to reference each other through future, as well as past, iterations. The ability to work and rework source material and arrive at differing visual results is another element that Heikes and Ruilova share.

Violette and Ruilova both incorporate music and sound as key associative devices. In two recent, concurrent gallery exhibitions, Violette used what critic Michael Wilson called "a still-fashionable fascination with deconstructed stoner rock and its associated, only semi-ironic post-Goth theatrics."[9] The soundtrack to the show was sound more than music, and elicited a palpable response in the viewer—an uneasy pain. While curator Shamim Momin explained, "He uses ideas of darkness, morbidity and horror to access a sense of the sublime,"[10] critic Lauren Ross argued, "It seems that Violette wanted to strike a blow against our current state of war and imperialism . . . but the thrust of his fight was blunted by the rock-star company it kept."[11]

During a recent studio visit, Ruilova described her use of language as obstinate. She selects words and sounds, encouraging the performers in her videos to repeat them over and over, as if they are a groan, a stutter, or a psychological tic. Although she uses words primarily for the feelings they convey, Gardar Eide Einarsson utilizes language as a type of code that the viewer must decipher in order to access the embedded references. Einarsson takes codes of subversion from ex-cons, bikers, skaters, militias, and outlaws, strips them of their rawness, and thereby elevates them to a pure aesthetics.[12] Like many artists of this generation, Einarsson is drawn to the darker side of life, but always at a

[6] Jan Tumlir, "Primal Dirge: Jan Tumlir on Sunn O)))," *Artforum* 44, no. 8 (April 2006), 93.

[7] Hamza Walker, "Goth Is Dead! Long Live Goth!," in *All the Pretty Corpses*, exh. bro. (Chicago: Renaissance Society at the University of Chicago, 2005).

[8] Brian Scholis, *Amie Dicke: Void*, exh. cat. (Amsterdam: Artimo, 2005).

[9] Michael Wilson, "Banks Violette: Team/Gladstone Gallery," *Artforum* 46, no. 1 (September 2007), 466.

[10] Vincent, "Death," 64.

[11] Lauren Ross, "Rock Out," *Art in America* 95, no. 10 (November 2007), 200.

[12] Amanda Coulson, "Frankfurt: Gardar Eide Einarsson, Frankfurter Kunstverein," *Modern Painters* 19, no. 9 (November 2007), 99.

remove—and often with a wry sense of humor.[13] He explains, "Work today sort of problematizes its own context… [artists are] now… questioning their own stands, being present in the work as a sort of interpreter, or failed interpreter."[14]

Ruilova's videos actively create an enframed space in which the action occurs and the viewer perceives. Her spaces are dimensionally contained within the televisual frame, while David Altmejd brings the grotesque into three-dimensions and enlarges it beyond human scale. Utilizing living and decaying plant and animal forms, gold chains, crystals, vitrines, and mirrors, among other materials, Altmejd presents and explores an alternate underworld marked by "death and desire, the self and the other, decay and transformation."[15] The references range from the Bauhaus to minimalism, the discotheque to horror and the Gothic. Critic Christopher Miles suggests that Altmejd's romantic search for the otherworldly—shared by the majority of young Goths and horror fans—is a means of escaping ennui.[16]

Most striking in the spaces created by Sterling Ruby are the variety of his productive oeuvre and the distance between his applied aesthetics. Formally, Ruby, like Altmejd, employs diverse and idiosyncratic materials, ranging from nail polish to ceramics. In content, his influences mirror Ruilova's and other artists of their generation: the Iraq war, *The Exorcist*, countercultures, anarchy, and the grotesque. His works are traumatic, touching upon such subjects as imprisonment and suicide. He also works in a self-conscious manner. In order to foreground his gifts as a formalist, Ruby "dials down the shock level to a low hum."[17]

Contrary to the restraint shown by Ruby, Sue de Beer shares with Ruilova an intense interest in developing, intensifying, and presenting the dramatic scenario. Ruilova and de Beer both utilize familiar, private spaces that can be imbued simultaneously with intimate comfort and psychological terror. Both create work in which dialogue is conspicuously absent. Ruilova uses repeated word or grunted sounds, de Beer near-silence. De Beer is concerned with affinities between viewer and subject, playing on notions of voyeurism. She builds environments in which her works are filmed and later exhibited, allowing the viewer to walk around and experience the same potentiality afforded her characters. Ruilova, instead, highlights the disconnect between actor and viewer in a traditional filmic sense, facilitating engagement in the form of a pure, disengaged spectator. Shamim Momin posits that de Beer's exploration of difficult and sensational content invites the possibility that "ambiguity, beauty, sincerity, terror, and perversity might combine to convey life's most precious moments."[18] The argument, although probably ultimately incorrect, is compelling.

Olaf Breuning shares de Beer's ability to create vast and vivid tableaux. Whereas she focuses on feminine characters, he typically concentrates on packs of male rogues. Both artists enact vaguely adolescent scenarios that culminate in gruesome outcomes. The absurdities of his narratives are akin to those employed by Ruby. They all deny the possibility of any single, coherent truth.[19]

[13] Bob Nickas, "Remember Kids," *Purple Fashion Magazine* 3, no. 6 (fall 2006 – winter 2007), 138.

[14] Ibid., 143.

[15] Jeffrey Kastner, "David Altmejd: Andrea Rosen Gallery," *Artforum* 43, no. 5 (January 2005), 180.

[16] Christopher Miles, "David Altmejd," *Frieze: Contemporary Art and Culture*, 88 (January – February 2005), 98.

[17] Michael Ned Holte, "Sterling Ruby: Marc Foxx," *Artforum* 45, no. 4 (December 2006), 315.

[18] Shamim M. Momin, "Come Back to Me: Making Your Amends," *Sue de Beer*, exh. cat. (New York: D.A.P., Inc., 2005).

[19] Michael Wilson, "Olaf Breuning: Metro Pictures," *Artforum* 42, no. 8 (April 2004), 156.

Similar narratives occur in the work of Matt Greene. The first painter to be discussed herein, Greene pulls imagery from botany, mycology, and horror films, and addresses themes of mysticism and morbidity.[20] His androgynous figures engage in decadent coupling as a means of escaping the dreariness of ordinary life. Like many of his peers, Greene's alternate vision is intended to offer a new sublimity, where darkness is a refuge from a mundane existence.

Escaping reality also permeates the work of Slater Bradley. Cleverly, Bradley achieves this by inserting someone else—who looks like him—into his own reality. His recent work features the man he has identified as his doppelgänger, his friend Benjamin Brock. As Paul Fleming writes, "Whereas the doppelgänger traditionally has the upper hand and calls the shots, Bradley seizes the initiative... [to take] possession of his doppelgänger, scripting, directing, and producing it." The twist continues as Brock's identity in Bradley's work is conflated with figures that have their own cult mythology, including Kurt Cobain, Ian Curtis, and Michael Jackson. As Bradley states, "Many of the issues I want to talk about are far too personal. Everyone can relate to the media and its superstars and heroes. Not everyone can relate to what I go through."[21] Like many artists of his generation, much of Bradley's work contains a romantic fascination with death, both his own and those of body doubles and cultural icons who have chosen to lay themselves to rest prematurely.

Critic Jerry Saltz offers another rationale for the emergence of death-focused subject matter in art made by young artists: "Ever since the Enlightenment killed off Satan in the eighteenth century, the artistic imagination has relished filling the void... yet it persists with sincere tongue in ironical cheek."[22] Aïda Ruilova and her generation of artists make work that is somehow philosophically different from the artists included in the 2004 Carnegie International. Their work is highlighted by a fascination with angst, the gruesome, and death, yet it simultaneously winks self-reflexively amid the melodrama and gore. Does it matter that viewers may not always grasp the irony? At a time when denial may be the most applicable term to describe American culture and Americans, the blame—if there is any to be laid—is probably best left to rest upon the viewers themselves.

[20] Rachel Kushner, "Rotten and Blissful: The Forests of Matthew Greene," *She Who Casts the Darkest Shadow on Our Dreams*, exh. cat. (Los Angeles: Peres Projects, 2004).

[21] Pelin Uran, "Journey to the Far Side of the Sun: Slater Bradley," *Uovo Magazine* 11 (2006), 157 – 69.

[22] Jerry Saltz, "Modern Gothic," *The Village Voice*, February 4 – 10, 2004, 85.

Cries and Whispers:
Aïda Ruilova's Early Singles

Laura Fried

Eliot once remarked, in a phrase I can neither quote nor locate exactly, that we know more than the artists of the past and that they are precisely what we know.

—Annette Michelson, "Camera Lucida/Camera Obscura," January 1973[1]

IN 1973, FILM THEORIST AND ART HISTORIAN ANNETTE MICHELSON MUSED ON THE THEN-CURRENT STATE OF VANGUARD CINEMA. Measuring the recent work of Stan Brakhage against that of his formidable forebears, Michelson triumphed the artist's critical contribution to the teleology of avant-garde filmmaking. At the apex of the experimental film explosion in the 1960s stood Brakhage, celebrated as a guerrilla and poet, who had once again reintroduced cinema as a plastic medium, a sculpted form. For Michelson, Brakhage offered a new position on "the paradigm of contemporary montage style"—what she saw as an optical space of film that rooted itself to the "uncorrupted dwellings of the imagination."[2] At the heart of Michelson's essay, however, lay a claim to an understanding of Brakhage that was inextricably wedded to and mediated through—from Soviet filmmaker Sergei Eisenstein's Constructivist approach to the distended "trance" structures of Maya Deren—the art of the past.

If Brakhage operated, as Michelson argued, in the perpetually reflexive realm of experimental cinema, the newest forms of which would be forever filtered through the lens of its own history, the video work of Aïda Ruilova roots itself firmly within this exchange. In 2008, four decades after the widely acknowledged "renaissance" of avant-garde filmmaking,[3] Ruilova emerges as a critical, accomplished presence in the annals of contemporary film and video art. Brakhage and other structuralists—along with Maya Deren and Andrei Tarkovsky, in particular—all belong to a cinematic past that Ruilova has come to know as a young artist and filmmaker at the turn of this century. Indeed, these names appear in much of the writing on her work, as the "influence game" has been played out by nearly every writer who has addressed her early videos.[4] At once deferential to this history—from Deren's trance aesthetics to the B-level horrors of Roger Corman and especially French sexploitation auteur Jean Rollin—Ruilova draws from a wealth of material she then absorbs and more importantly, corrupts, for the controlled frenetics of her own compositions.

In a dark gallery, television monitors on narrow pedestals huddle together in an imposing mass. Suddenly, in a series of flashes and sporadic groans and grunts and, occasionally, a squeaky voice trilling, "Beat... perv!," a sequence of episodic videos surrounds the viewer in spasms of image and sound. A voice groans, "Do it...," as an overwrought, headphone-clad girl thrashes on a mattress. Another monitor begins to flash a pair of hands screeching a vinyl LP across a dank stone wall. On yet another screen, a sallow-faced zombie skulks across the frame, growling an uneasy "3-2-1" countdown. Another flash, and a young blonde crouches in a dim stairwell, chips at peeling paint, and gnaws at her shaking fists. Preying on the viewer's physical presence within the space, Ruilova's terse single-channel videos together threaten to assault the senses, jerking with nail scratches and maniacal

[1] Annette Michelson, "Camera Lucida/Camera Obscura," *Artforum* 11, no. 5 (January 1973), 36.

[2] Ibid.

[3] Wheeler W. Dixon and Gwendolyn Audrey Foster, *Experimental Cinema: The Film Reader* (London: Routledge, 2002), 7.

[4] Notable are essays by Ingrid Chu and Barry Schwabsky in *Afterall* 13 (spring – summer 2006): Ingrid Chu, "Aïda Ruilova: and Again. . . ," 72 – 80; and Schwabsky, "Vampire Video: Time in the Art of Aïda Ruilova," 65 – 71.

giggles and carnal moans. On adjacent walls, two projections reveal similar, if perhaps stretched, conditions of disquiet.

In both Ruilova's abbreviated monitor works (rarely do they endure for more than a half minute) and single-channel projections, which maintain an indefinitely strained climax, we encounter an ominous vision of bewitched private space. The camera rarely travels in these focused vignettes, where movement is created almost exclusively through Ruilova's layering of crosscut shots and montages. These clipped gestures and incantations, dismembered and then recomposed, foreground each video's shape and texture. Largely characterized by dark, confined interiors and lone protagonists suspended in chronic states of psychic distress, Ruilova's videos reveal an attention, in fairly equal measure, to structures of music, performance, and film. A founder and one-time member of the experimental band Alva, Ruilova is keenly aware of the place of sound in her pieces, where single, screeching vocals and repeated one-liners (often marking each work's title) are cut and compounded into slashing, percussive pulses. Slicing and resculpting each layer of agonized expression and desperate whimper—and in steadfast refusal of any satisfied resolution— Ruilova thus presents a dissonant composition of contained hysterias. And yet, in this symphony of moving image and sound, a perpetually sustained crescendo of suspense inevitably creeps into our physical space.

While Ruilova's work might nod to a kind of post-punk conceit, her attention to experimental cinematic techniques has largely informed this early work. At the turn of the twenty-first century, Ruilova attends to the aesthetics of metered montage with which Soviet vanguard filmmaker Sergei Eisenstein so shocked his audience in the late 1920s. In many of Ruilova's early single-channel works, abbreviated gestures and compressed but focused shots create an elliptical structure of terror-infused imagery. The hysterical impulse remains a central motif in these works, where, on the one hand, Ruilova often captures her unstrung characters in chronic fits of frenzy and torment, and, on the other, heightens the effect with an electrified assemblage of clipped shots. Eisenstein, for one, operated under his own dictum that a viewer's psychic and emotional response can be elicited, even strengthened, through composition and editing.[5] Perhaps without Eisenstein's Soviet, propagandistic punch—"It is not a Cine-Eye that we need but a Cine-Fist," he once wrote[6]—Ruilova nevertheless games on his "reflexological" attack on the spectator. And so, too, for Ruilova, sound is treated as a critical object to be disfigured, resisting the theatrics of the screen and the film's capacity for illusionism—all in favor of form itself as a psychic, kinetic construct.

Not to be ignored, of course, is the experience of Ruilova's works in the space of the white-walled gallery. To be sure, the position of Ruilova's spectator within the space—her presence among a cluster of monitors that key abruptly on and off—becomes a critical element of the artist's conception, and one that recalls similar strategies adopted by an earlier generation. Throughout the 1960s and '70s, avant-garde artists and filmmakers, wishing to explore the relationship between the projected and physical space, had turned their gaze back to film and the projected space

[5] See chapter 3 of David Bordwell's *The Cinema of Eisenstein* (Cambridge: Harvard University Press, 1993).

[6] Sergei Eisenstein, "The Problem of Materialist Approach to Form," in Richard Taylor and Michael Glenny, eds., *Writings: 1922-34*, trans. Michael Glenny (London: British Film Institute, 1992), 64.

as bodily constructs. Those who came to be known as structuralist filmmakers, such as Michael Snow, worked to extend beyond what Gilles Deleuze called the "movement-image" of the flat cinema screen, and instead cast the experience back into the physical space of projector and spectator. For others, like Stan Brakhage and Tony Conrad, film itself came under attack as a plastic medium to be perverted. For many artists of the time, the divergences between the perception in real space and time, the experience of *mise-en-abyme* structures in film, and the flat surface of the film itself were all deeply imbricated.

Drawing from these very tensions, as if in direct dialogue with these progenitors of contemporary vanguard film, Aïda Ruilova amps up the strain between actual and filmic space. If, on the one hand, experimental film had become a part of Ruilova's vocabulary in film school, a similar phenomenological focus—of projecting the experience of film back into physical space—informs her decision of how the work must be shown. In *Oh no* (1999), *You're pretty* (1999), *Beat & Perv* (1999), *Hey* (1999), and *no no* (2004), Ruilova emphasizes the compressed atmosphere within each frame, further constricted by the work's elliptical structure. And yet, the viewer is implicated in the arrangement, at once accomplice to the caged terror behind the monitor's screen, and contained within the physical frame of Ruilova's synchronized display. As she remarks on the capacity for both the montage technique and her installation to captivate the viewer: "Fractions of a second add up to something, making just a second feel like an eternity when I edit... I like to show these works in lit rooms in a sort of reversal of space and projection. The on-and-off quality to the works and blinking of the images become as fleeting as a light turning on and off. I like to think of these single-channel short-format videos functioning as 'in one eye and out the other' all at the same time."[7]

At film school in the late 1990s, Ruilova immersed herself in experimental film—from diary to structuralism, trance film and animation—"all short form and non-narrative," she says.[8] Working in 16mm or Super 8, Ruilova would often flirt with traditional film equipment: Nagra sound recorders, cutting and splicing stations, optical printers, "boxes full of old films to be used as found footage," and Steenbeck editing machines. For Ruilova however, this introduction to vanguard cinema histories, and to classic equipment, quickly shifted into a more impassioned affair with digital video out of the classroom. The condition of video as a "cheap, fast, and immediate" medium appealed to Ruilova, who sought to break away from the tactile, terminal process of cutting hard film. Video offered her a more pliant, manipulative material—one she could "trash." "With video you could shoot endlessly," she says, "meaning a bigger net. And you could cut it as much as you wanted since you didn't have to worry about tape splices ripping apart, if you cut four or five frames one right after another. It was digital and considered the whore to film." She adds wryly, "I liked working with the whore."[9]

As with the lure of video-as-whore, the perversion of the filmic medium—from temporal continuity to historical referents—remains a central rule in Ruilova's aesthetic and conceptual game. In *The*

[7] Email correspondence with the artist, March 10, 2008.

[8] Email correspondence with the artist, March 15, 2008.

[9] Ibid.

stun (2000), a headless, fur-garbed figure clenches the cracked jaw of a bearded man seated before her, and in an extended, mangled take, the frame shakes under the din of audio feedback. The woman's grip shifts slightly between each rapid-fire cut, as her fingers grasp at her victim's gaping jaw. Ruilova, having scanned and spliced a series of shots, weds the quivering sequence of frames with the sounds of wheezes and purrs she has captured from her digital scanner. In this protracted series of terse jump cuts, the camera's constricted frame seizes the pair in a suspended, epileptic stagger.

In part, Ruilova draws from Francis Bacon's sinister portraits of Pope Innocent X. As in Bacon's series, the caged isolation of Ruilova's figures and their strained, gaping features are bound in an unrelieved state of distress and disfiguration. So characteristic of Bacon's painting, Ruilova also captures a mouth wide open in a desperate scream, the figure's eyes veiled and his face consumed by the manic movement of the frame. Structurally, however, *The stun* also recalls the assemblage aesthetic of 1960s experimental film. In 1966, when filmmaker and musician Tony Conrad released his super-structuralist short *Flicker*, the film was prefaced by a warning that its frenetic pacing might induce seizures. As the thirty-minute episode bursted out a series of black and white blinks, continually built and broken in an extended crescendo-diminuendo, a single blast of stereophonic buzz comprised the soundtrack. If *Flicker*, one of the essential American avant-garde films, offered a kind of hypnotic vision of film as material, *The stun*, as with Ruilova's other early video work, registers a violent shock, where each flashing frame punctures the one before it like a savage gash. And if *Flicker* revealed an "audio-visual object whose most striking characteristic was the overall shape,"[10] Ruilova suffuses this structure with oblique terror, imprisoning her pair within the strangulated space of the composition, caged by a convulsing frame.

These structures, however, all work to amplify what is a ruling vision in Ruilova's work—that is, a fascination for the macabre. Looking to Roman Polanski's *Repulsion* or *The Tenant*, Robert Altman's *Three Women*, and *Last Year at Marienbad* by Alain Resnais—not to mention the films of Andrei Tarkovsky, Roger Corman, and of course, her horror-genre mentor Jean Rollin—Ruilova relies on the central role played by interior space as a psychic construct, transformed in her videos as unstable sites of fear or foreboding.[11] "In these films," she says, "the physical spaces were as much the subjects as were the actors."[12] While these derelict stairwells and dank cellars might heighten the sense of the captive frame, so too do they offer an otherworldly realm, where claustrophobic private space bodes a more sinister nightmare. If "montage is conflict," as Eisenstein would have it, then Ruilova's early videos gamble on the materialization of both terror and trauma. Distress and disorientation reign in these works, where paranoid glances, fits of alarm, and desperate, grasping gestures from her actors, coupled with hurried crosscuts, stress the threat of the unseen.

Looking in particular to the vanguard techniques of montage and filmic rupture as strategies of effective cultural production

[10] P. Adams Sitney, "Structural Film," *Film Culture* 47 (summer 1969), 1 – 10; reprinted in Dixon and Foster, *Experimental Cinema*, 236.

[11] Email correspondence with the artist, February 22, 2008.

[12] Ibid.

and political action, Annette Michelson triumphed those artists who "invent strategies, vocabularies, syntactical and grammatical forms for film... whose innovative functions and special intensity of energy are radical, defining the possibilities of the medium itself for their contemporaries."[13] Yet, the disembodied fury of montage—taken up by Ruilova many decades later—as a reaction to contemporary culture and a reflection of an unhinged psyche, prefigured even Eisenstein's revolutionary *Cine-fist*, which Michelson so passionately championed. Indeed, the ur-image of montage as a terror-suffused psychic construct emerged in the punctured, disembodied structures of war-weary Dadaists. Forecasting a strategy that would be considered endemic to radical cinema, the montage impulse figured prominently in the movement's founding document, the "Dadaist Manifesto," of 1918:

> The highest art will be that which in its conscious content presents the thousandfold problems of the day, an art which one can see has let itself be thrown by the explosions of the last week, which is forever gathering up its limbs after yesterday's crash. The best and most extraordinary artists will be those who every hour snatch the tatters of their bodies out of the frenzied cataract of life, holding fast to the intellect of their time, bleeding from hands and hearts.[14]

In 2008, Aïda Ruilova continues to mine both aesthetic and intellectual material from the trove of film's early and recent history. Digesting the cinematic ideograms of Eisenstein, the hypnotic, otherworldly realms of Deren and Tarkovsky, and the fecund eroticism and horror of Rollin, Ruilova has committed herself to reckoning with the position of her videos as the offspring of these filmic forebears. And yet, while Ruilova's early video work is undoubtedly a reflection of the past, her perversion of these constructs allows for a new take on film's capacity to prey on its viewer. Her *Strike-cum*-slasher-movie constructs at once privilege a private madness and morbid possession. Puncturing the insularity of these creepy underworlds, however, Ruilova pushes past illusionism and penetrates our physical realm. If we find ourselves at a moment of collective horror and personal torment—between the terrors of war and threats of public disaster and private ruin — Ruilova's art of darkness indeed captures the "frenzied cataracts of life," where, holding fast to the distresses of the day, it confronts us with an irresistible, if terrible, vision of ourselves.

[13] Michelson, "Camera Lucida/Camera Obscura," 30.

[14] Richard Huelsenbeck, "En Avant Dada: A History of Dadaism," in Robert Motherwell, ed., *The Dada Painters and Poets: An Anthology*, 2nd edition, trans. Ralph Manheim (Cambridge: Belknap Press of Harvard University Press, 1989), 40.

The Singles

Oh no_1999_0:42

Oh no begins with a low-angled, handheld close-up of a young woman trudging forward with panicked breath. She moves through the interior of a small apartment, repeatedly whimpering the phrase, "Oh no." Then, a quick cut to a sweeping close-up of an electric-guitar neck, as the squelching drone of distorted noise plays counterpoint to the rhythmic, frenzied breathing and increasingly plaintive screams. The view of the woman is upended as the camera punches in on her feet, which nervously navigate a pathway of electric guitars laid head to bridge. The initial shots are repeated and intercut, punctuating the anxious walk with screams, manic giggles, and growling distortion. The woman is only depicted in extreme views, flipping between high-and-low-angled close-ups of face and feet as the camera moves along with her. Although the guitar noise and the use of guitars as props refer directly to music, in this, and in many of Ruilova's works to follow, music is used both as an associative element within the work and as an intentional effect of the sharp, rhythmic editing.

The earliest work in the exhibition, and the first video Ruilova made after working primarily with 16mm film, *Oh no* reveals two dominant strains that run throughout her work: horror-movie aesthetics and music.

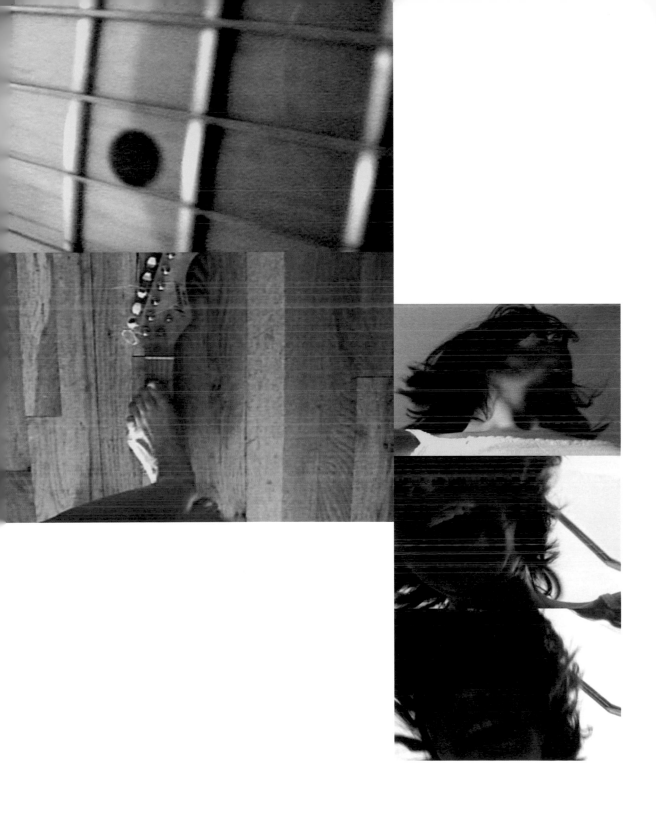

Hey_1999_0:30

Hey intermixes a number of unsettling images and sounds to create a sense of tension and foreboding similar to *Oh no*. Like *Oh no*, there is a dynamic interplay between the actions in the work, the sounds created because of these actions, and the overall soundtrack that results from this repetition and metered editing of diegetic sound. *Hey* is set in a claustrophobic apartment-stairwell space. Stairs creak as the camera moves up over the face of an incapacitated female character. Immediately, this shot is countered by a shot from below of the same woman, this time standing, striking the stairwell with a metal bar and nervously whispering, "Hey!." In the following shots, she taps her fingernails on the banister, the banister shakes violently, and the woman hangs precariously from a metal ladder.

As the shots begin to repeat, the compression of time—so characteristic of Ruilova's video work—becomes even more apparent. In one shot, the camera looks back up the staircase toward the light of an open window, peering past the woman as she lies on the stairs, flailing on her stomach. Later, we see one of her legs sticking out from behind the banister, twitching, illuminated only by a bit of light that appears to emanate from the same open window. By offsetting and intercutting light and darkness, sleep and wakefulness—the most common ways that we experience and mark the passing of each day—Ruilova disrupts narrative's traditional time flow.

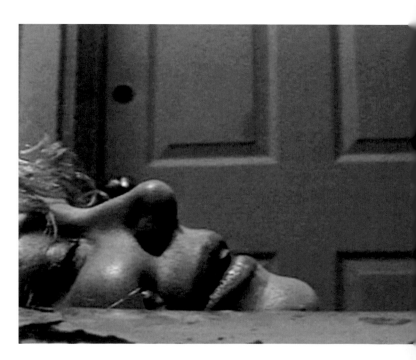

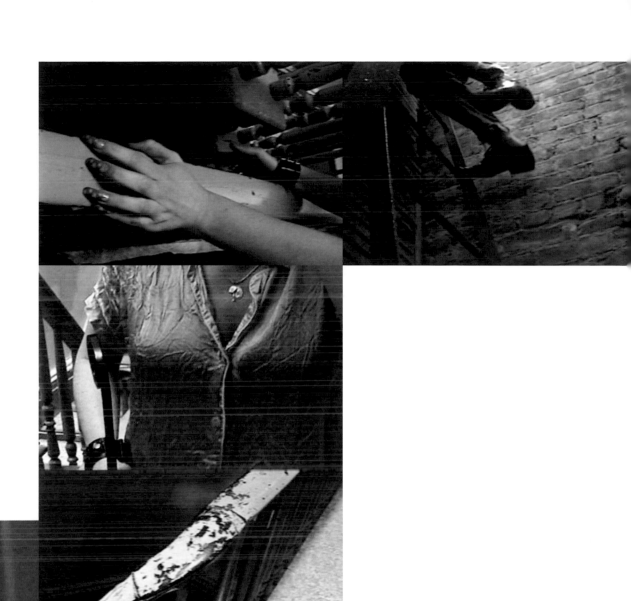

*You're pretty*_1999_0:36

Ruilova's earliest work to feature a male protagonist, *You're pretty* is set in a basement-like room with cinder-block and roughly hewn stone walls. A long-haired, shirtless man kneels at the end of a long, dark hallway, hugging a guitar amplifier, rocking it back and forth, while repeatedly cooing, "You're pretty." A series of oblique views of the man follow, intermixed with shots of a vinyl LP being dragged along the rough stone wall or scraped against the concrete floor. Suddenly, we see the man's face as he stands, almost stumbling toward the camera, shrieking with surprise. Alternating with repetitions of previous shots, the man whimpers, sedately drones into a cheap microphone, and attempts to pry out the speaker from the back of the amplifier.

While the claustrophobic settings of both *Oh no* and *Hey* do much to control the action and mood of the respective works, the space in *You're pretty* becomes as much a character as the actor. It has distinct, darkly associative qualities absent from the domestic interiors of *Oh no* and *Hey*, and contributes directly to the overall tone of the work. The interaction between character and setting thus becomes intensely physical—the collision between the two directing movement and producing much of the resulting soundtrack.

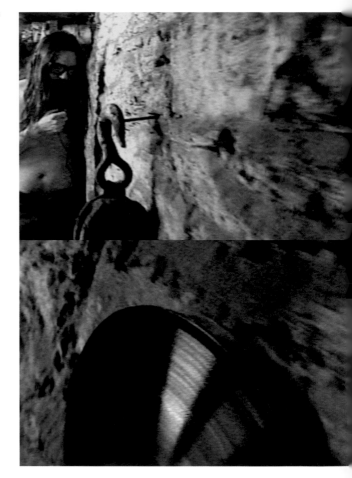

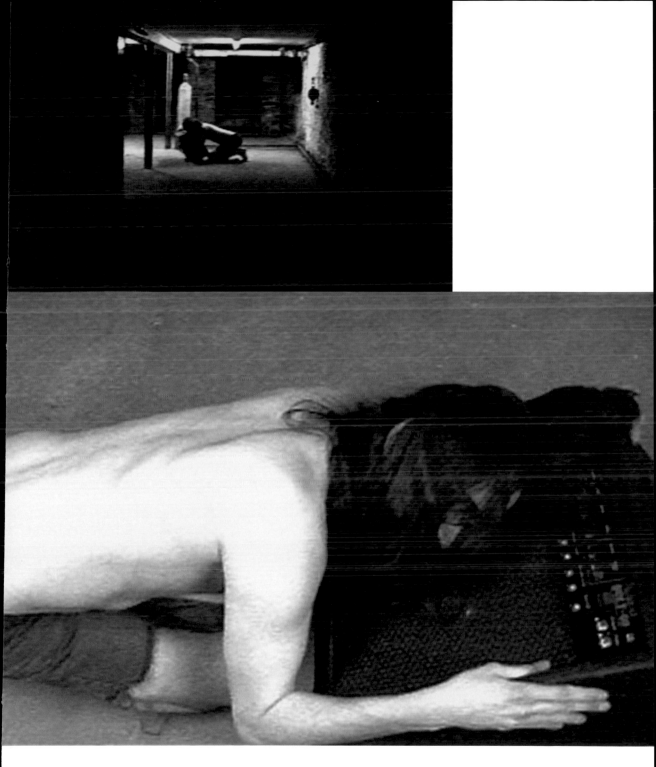

Beat & Perv_1999_1:25

Automaton gestures and drumbeats make up this early video, in which the artist thumps her bruised face against mirrored screens and trills, "Beat, bu-beat, bu-beat… beat perv!" Drawing from the motions of Motown backup singers—twin dancers who dip and sway in unison—Ruilova composes an unsteady rhythm of sound and doubled image. Facing a mirror, her gaze directed back at the camera, she hurtles forward and back, intoning, "Beat, bu-beat, bu-beat!" Quickly, the camera cuts to a pair of bare legs bending and locking, and the beat continues. In a sequence of collaged close-ups, a shoehorn clicks across a radiator, a drumstick raps and clinks, the figure mouths the beat in silence and then repeats the words out loud, rocking against a slanted mirror. The pair of legs dips together as two hands hang loosely above them, until, finally, the figure sways forward and falls back out of frame.

Beat & Perv—its title a simple reduction of the video's structure—aims to corrupt (or pervert) its own rhythm and symmetry. While mirrored images and repeated clips offer a low-tech solution to synchronized movement and sound, Ruilova's abrupt and fractured editing, coupled with the uneven beat, resists a steady tempo and uniform, linear composition. Here, as in many of the artist's early single-channel works, abbreviated gestures and compressed but focused shots instead foreground the video's elliptical structure. Ruilova's double self, chanting compulsively between irregular drumbeats—a twisted take on the music video genre—offers a dark approach to this percussive performance.

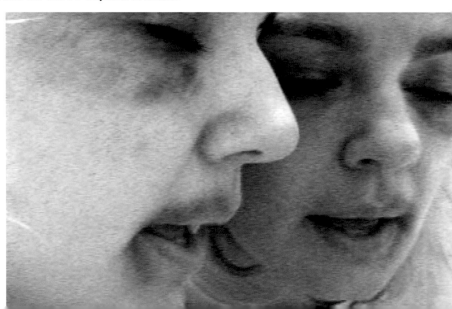

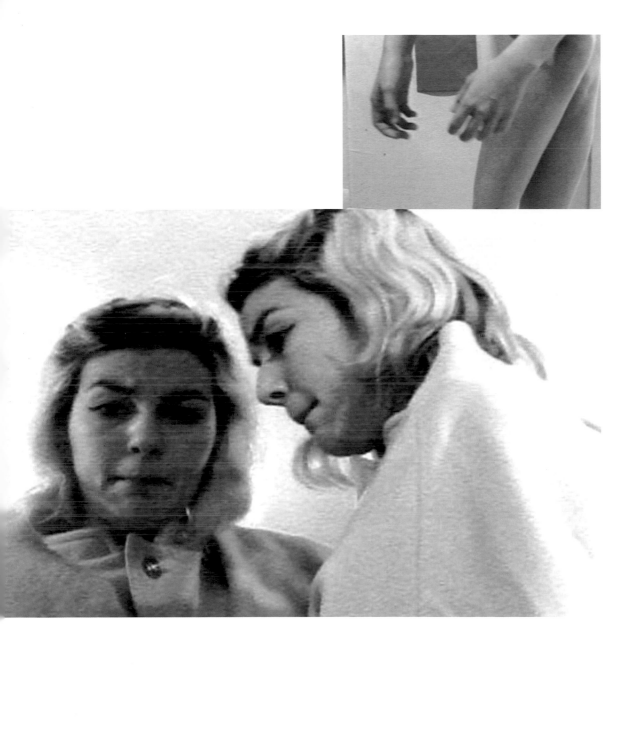

Do it_1999_0:31

Do it features a series of close-up shots of Ruilova as she gasps and writhes across a bed and against a wall, clasping headphones over her ears and croaking the words, "Do it...." In a rapid-fire sequence of groans, rasping shrieks, and grunts, Ruilova captures a staccato of frenzied, repeated gestures. An agonized torso—headphones and cord tangled around her head and neck—flails and screams. A disembodied hand grasps and shakes a wooden sconce on a bare wall. At intervals, the figure, with a sedate and yielding gaze, lies motionless, uttering, "Do it...."

Again, Ruilova creates a prismatic structure of moving images—a sexed figure thrashing on a bed, a screaming face covering the camera's lens, a desperate, grasping fist. Yet, as the tension percolates with episodic cuts between fits of hysteria and submission, Ruilova refuses any climax in favor of contained but sustained frenzy. Under the aggressive command of the camera's lens, the artist's cloistered figures are often tormented, feverish, or bewitched. Here, in *Do it*, as in her other early works, the artist games again on the physical form, in both body and film, of psychic distress.

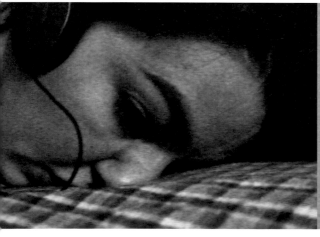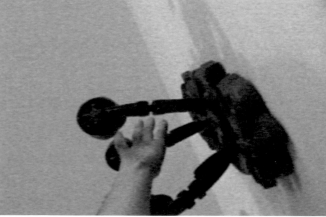

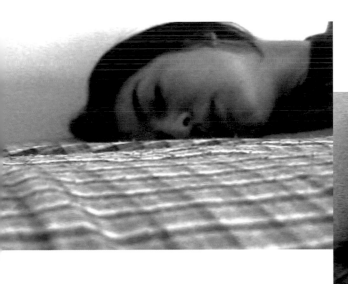
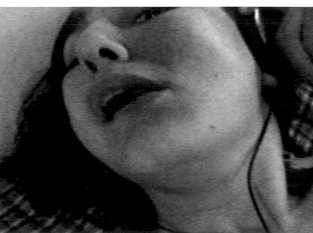

The stun_2000_2:00

Frenetically spliced cuts and stop-motion sequences together offer a single, if not still, image in *The stun*, in which a fur-clad figure grips the open jaw of the man seated before her. A break from her earlier videos, Ruilova here keys up the frenetic pace while holding the camera's focus on a distinct subject and frame. In a series of slightly varied shots that have been scanned and spliced digitally, Ruilova composes an epileptic image that she then couples with the grating low hum and hiss of her digital scanner. The effect is a distorted and fraught portrait of grotesque disfiguration.

Drawing from Francis Bacon's haunting portrait *Study After Velázquez's Portrait of Pope Innocent X* (1953), Ruilova creates a sustained tension between still and moving image in *The stun*. Here, the woman grasps her victim's open jaw like a vise, her fingers curled over his teeth, while her palm pushes his nose up and back. As in Bacon's series, the caged isolation of Ruilova's figures and their tense, gaping features tie them to a perpetually tethered condition of distress. So characteristic of Bacon's painting, Ruilova also captures a mouth wide open in a desperate scream, veiled eyes and a face corroded by frenetic editing. Even without the isolation booths in which Bacon stranded his figures, Ruilova's pair is imprisoned within the seizing space of the frame.

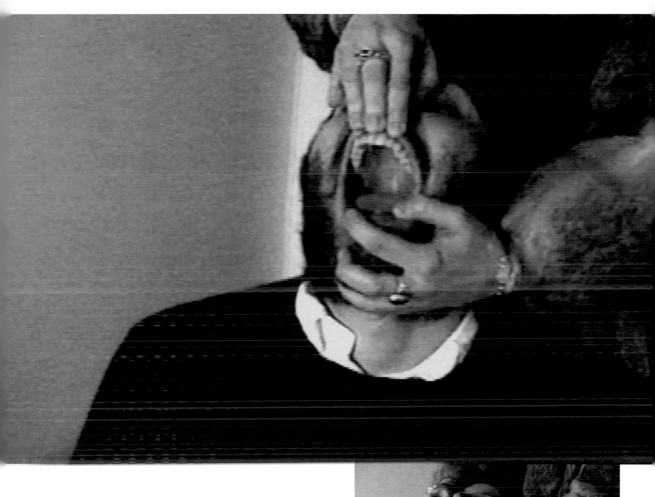
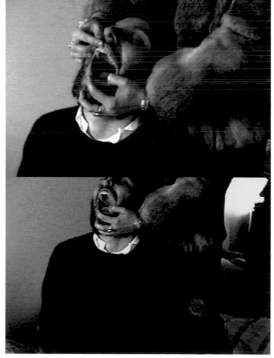

*tuning*_2001_1:16

Tuning begins with an abstracted, out-of-focus image and the repetitive strumming of a detuned guitar—a short excerpt from a song on the seminal Sonic Youth album, *Confusion Is Sex*. As the music drones, the picture slowly pulls into focus, revealing a head-on shot of a man and woman sitting motionless on a couch, holding hands, and staring back at the camera. The music stops, and the moment the image comes into sharp focus, it abruptly cuts to black, only to begin again after a brief pause. As the shot repeats, subtle variations in the soundtrack seem to creep in—a slight screeching sound, some barely audible hiss or distortion—but just enough to question whether or not the work is truly looping. *Tuning* explores a parallel notion of correctness in both photographically-based mediums and music: being in (or out of) focus and tune, and the implications for experimentation with these norms for both artists and musicians.

Featured in the work is French erotic-horror director Jean Rollin. A strong influence on Ruilova's work, Rollin's films are bare, ethereal narratives that focus on distinct, spectacular locations that the filmmaker has used again and again for more than thirty years. Set in Rollin's home in Paris, the work is more than an homage to influence—it is a rumination on the frame itself.

Come here_2002_0:29

Opening with a burst of quick shots and contrasting sounds, *Come here* further explores Ruilova's penchant for creating a "musical" soundtrack. Like *You're pretty*, *Come here* features a single male actor, dressed in a shirt, patterned in gold sequins that follow the contours of a muscular torso. While roaming around a dilapidated space littered with a variety of overgrown plants and a single loudspeaker hanging from the ceiling, he both whispers and mouths the words, "Come here." Once again filmed from oblique angles and framed with a claustrophobic closeness, the video captures the man lying on the floor, arms outstretched, holding the speaker aloft with one hand, and staring menacingly at the camera. These shots are offset by him wandering, somewhat aimlessly, or holding the speaker in the air, this time listlessly spinning under it while humming. Again, there is a juxtaposition of stasis and action, of quiet repose and physicalized anxiety.

As with other sets for Ruilova's works—notably in *Hey, I have to stop*, and *no no*—the interior is punctuated by light streaming in from an undefined exterior, adding to the decentering of the interior space. The set here is the space in which the man in the video actually lived, common for many of the settings of Ruilova's early works.

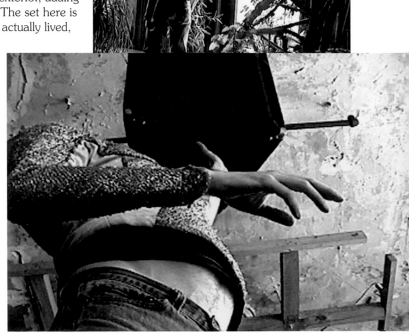

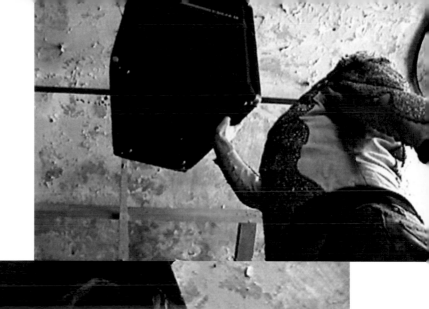

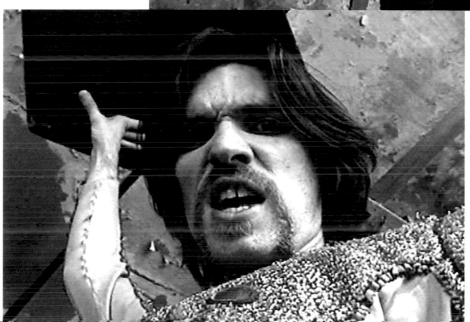

I have to stop_2002_0:33

I have to stop focuses on a single female, this time in a dark, basement-like interior, with light peeking in from overhead concrete grates and barred windows. In a gesture reminiscent of *Come here*, the woman hangs from the grate, either facing the camera or climbing the grate with her back to the viewer. We hear a mixture of childlike humming and the nervous whispering, this time punctuated with scenes of the woman shaking against the grating and babbling nonsensically. Whether she is clinking her rings on railings or rattling bars, there is an empty, almost unmotivated quality to her actions.

While not wholly static, the woman in *I have to stop* moves less than the actors in Ruilova's earlier works. Instead, it is the movement of the camera that animates the character, whose jerking, repetitive gestures mimic a zombie's nearly flat affect. It is this tension within affect— between the experience of emotion and its outward expression, between the isolated actor and the isolating inability to connect with an outer world—that becomes an oblique focus of much of Ruilova's work.

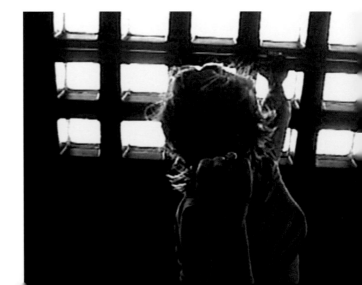

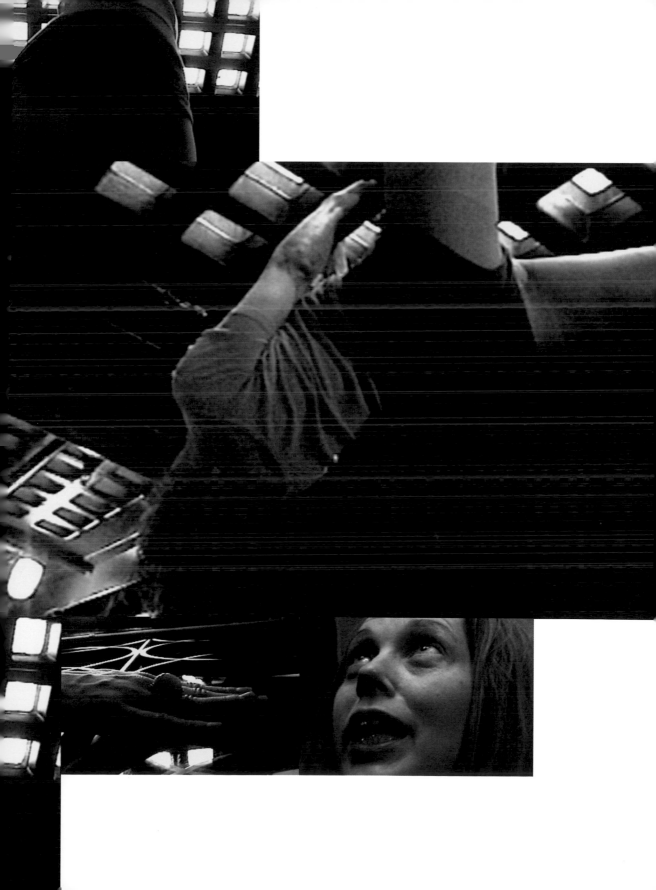

*Almost*_2002_0:19

The narrow stairwell, with peeling paint and rickety banisters, operates as a main character in many of Ruilova's single-channel works. These confined sites, in which her actors are posed in various stages of arrest or captivity, offer little space for escape from the constricted frame. Among these cramped scenarios is *Almost*, where in a derelict stairwell of an old apartment building a blonde girl in yellow shorts crouches on the steps, glaring up with clenched fists as spit falls from her lips. In a sequence of repeated shots, she shakes her hands in front of her gritted teeth, presses her upright body against the wall, picks at peeling plaster, and clambers up along worn stairs. Captured by close-ups and extreme-angled shots to heighten her containment, the girl drools, snarls, and with an animal gaze prowls through the caged space.

Almost, like Ruilova's other elliptical video works, draws from both the montage aesthetic of early vanguard cinema and horror-film suspense. Amplifying the tension between sound and image, Ruilova collages together the truncated images against the feverish rapping of a cymbal, each shot doubling and repeating as the physical and psychic tension mounts. These incisive and extreme slices of action, intensified by Ruilova's serialized technique, offer a contained, cyclical composition of paranoia and private madness.

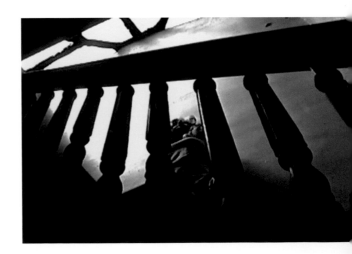

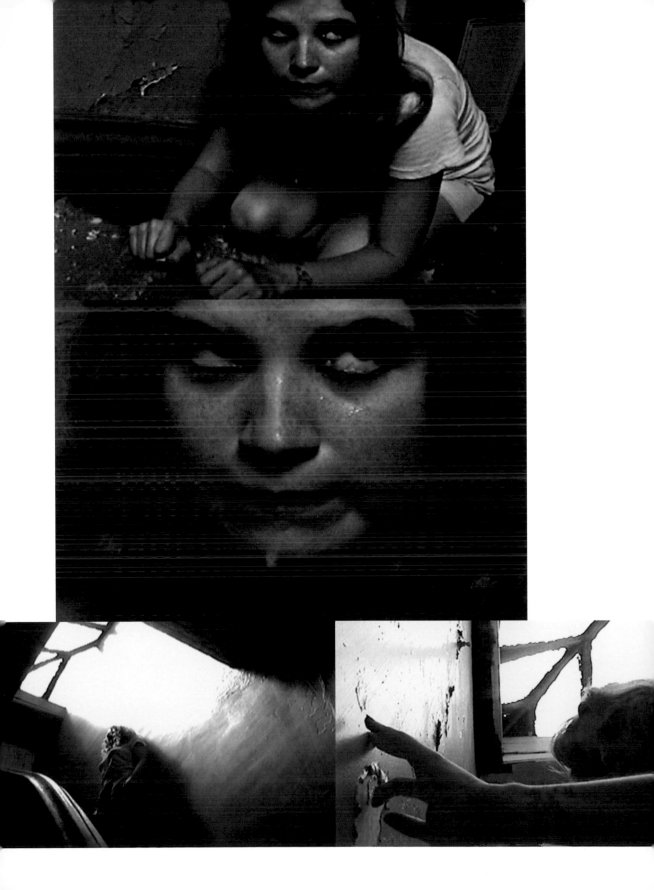

*3,2,1 I love you*_2002_0:14

A lanky figure inhabits dank basements and ramshackle stairwells in this terse montage, in which, among a series of grunts and gasps, a skeletal hand waves a 3-2-1 countdown. Between fragmented shots of movement within these contained spaces, the protagonist episodically cocks his head upside down on the carpeted corridor floor, tenses his hand, and gruffly mouths the words "I love you" at the low-angled camera. Ruilova again has the measure of the horror-movie monster, who skulks across a narrow landing, crawls along the floor, and creeps toward and claws at a barred basement window. And yet, while the pale, bony-faced, spindly-limbed giant slinks ominously across the frame, he occasionally reveals, with a backward glance, a fear of an Other, unseen.

Ruilova's actors, filmed at extreme angles, often appear possessed, at once irrepressibly tormented and yet clamoring to escape. In *3,2,1 I love you*, the tortured figure prowls through Ruilova's claustrophobic set with a zombie's haunted expression and the desperate but childlike gestures of Frankenstein's monster. With characteristic foreboding, Ruilova builds tension with a collage of compressed moments of action and sound that evidences an oblique and sinister secret world. Here in this charged work, featuring a ghoulish hero, caged spaces, and a countdown without end, Ruilova centers on a macabre expression of the contemporary Gothic.

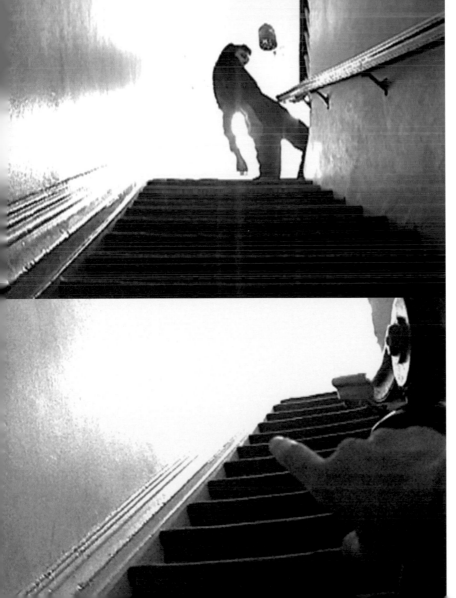

Untitled_2002_0:58

In this short, looped work, Ruilova films a woman sprawled across the arm of a Titan jib crane, her motionless body flung along the camera's base, as both she and the crane repeatedly pitch forward and draw back. To the sound of labored breath, the Titan lurches forward and retreats, and the low tide washes in and out on the flat shore behind it. As the breath grows increasingly asthmatic, the woman and crane heave forward and back in syncopated fits and starts, and finally, in one rasping exhalation, they rise up and out of frame.

Taking as her source material Jean-Luc Godard's film *Sympathy for the Devil*, Ruilova restages the final film-within-a-film sequence on the beaches of the Texas Gulf Coast. In Godard's 1968 counterculture documentary (also known as *One Plus One*), actress Anne Wiazemsky plays Eve Democracy, who stumbles along the sand as a camera crew tracks her path and a director splashes her with fake blood. In the closing shot of the extended pan sequence, Eve Democracy is hoisted lifeless and bloody around the camera end of a film crane. Here on Texas's Mustang Island, Ruilova re-creates this elegiac scene with a handheld camera to reveal a scenario at once alien and familiar.

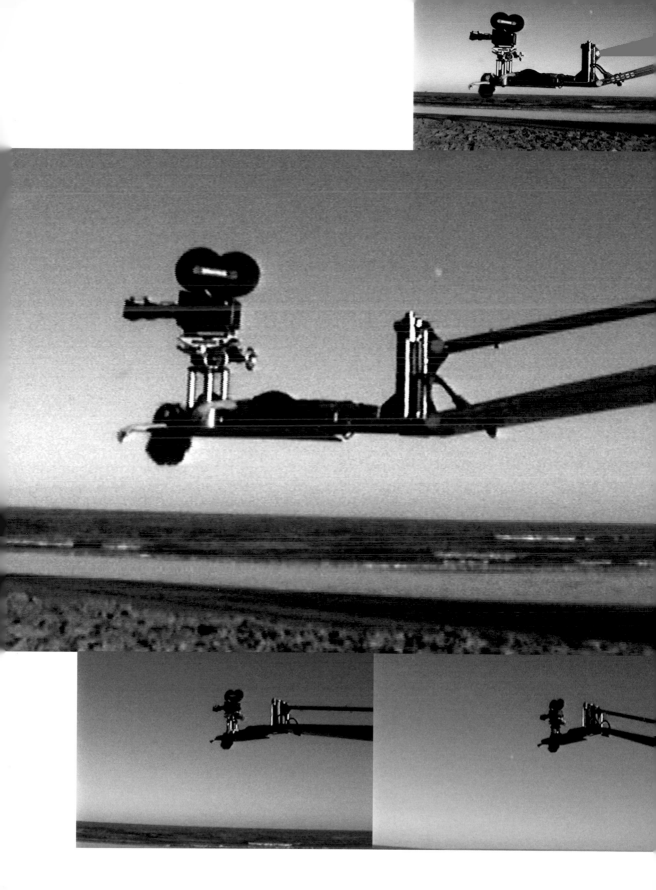

*Untitled*_2003_0:58

At a craggy edge of a misty shore, a woman lies in the sand with
a reel-to-reel audio recorder strapped to her back. Synchronized
to the sound of wheezing gasps, the tide pulls in and out in time
with the inhaling and exhaling of gasping breath. The woman lies
stiff on the shore—clad in black boots, arm flung forward over
a rock's edge—while the audio reel jerks forward and back with
the camera's cuts. Shot along the coast of Big Sur, California,
Ruilova again chooses as her paired subjects the lifeless heroine
and an iconic emblem of filmmaking. The woman's back is to
the camera, a Nagra recorder slung over her shoulder; as she
lies motionless, the reel plays in clipped spasms, mirroring the
wheezing soundtrack. Ruilova offers both an echo and counterpoint
to her work from the year before. Like its sister video which shares
its sound, Ruilova again has the measure of the melancholic finale,
when, in the last moments of the short sequence, the hissing
breath releases in an extended and labored exhalation. In both
self-referential works, Ruilova offers a solipsistic take on notions of
private space and the artist's relationship to film.

*It had no feelings*_2003_0:21

we went over to the place
we walked up the stairs
i had no feelings
i was holding onto a hand
it was dark
we stopped in front of one of the doors
it put the brown bag over my head
i don't remember seeing through the holes punched out
i remember knocking and light poured out the door
it was right in front of me
tall with no voice
i couldn't hear a heart

Quickly zooming outward to reveal two women standing in a pool, arms outstretched with palms placed flat on the edge, their faces brightly spotlit, *It had no feelings* opens with and is structured by the characters reciting the above narrative. Recited in quick monotone, the jumps, slips, and repetitions in the narrative are created by Ruilova's staccato editing. The video jumps from different angles to shots of the same scene.

It had no feelings is one of Ruilova's earliest works to feature multiple actors. Here, she draws from an early memory that she retells in this ambigous but charged text. In the process of detaching herself from the narrative, Ruilova brings in the viewer. Denied the specifics, we are left with the emotional overtones and suggestive shell of the narrative, creating a space of projection and empathy for the viewer.

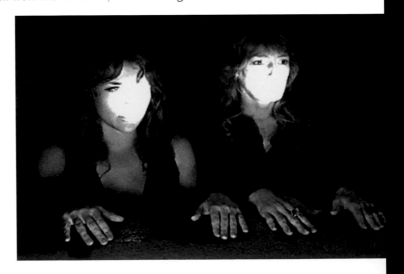

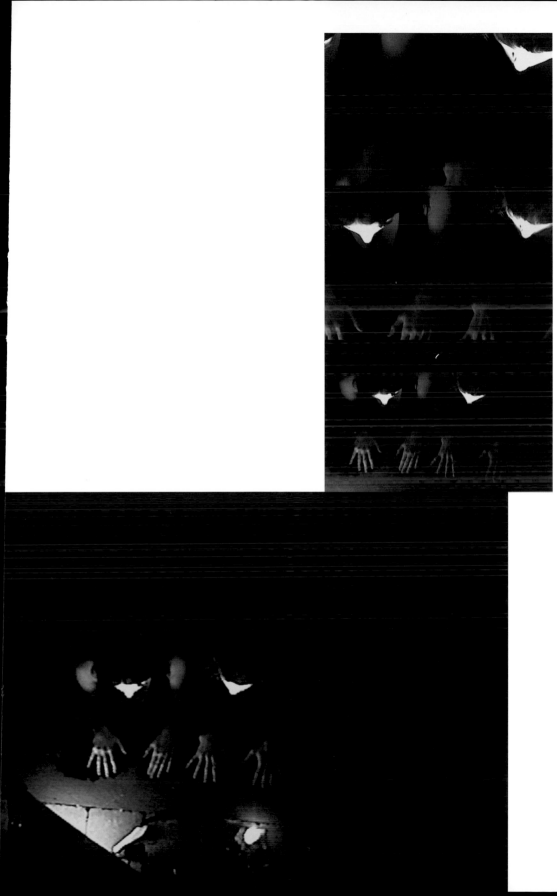

*no no*_2004_0:13

Cymbals crash. A young, bearded man runs back and forth across a room. Suddenly, he stands on a small table, peering through a skylight. The camera spins, first left, then right, as it frames him from below. In the next shot, he is shown jumping in place, and, after another edit, he is on the ground, crouched over and shouting "No, no" with clenched fists.

Again, the physical setting of the video—another apartment—is punctuated by windows and light. This time, however, a recognizable element of the exterior world is visible: as the camera spins, the man peers down through the skylight, framed by the pale blue void of an empty sky.

The shortest work in the exhibition, *no no* is tight and compressed, with finely controlled movements of actor and camera. The handheld-camera work, dominant in Ruilova's earliest monitor pieces, is increasingly tempered by tripod shots utilizing quick sweeping pans and zooms. This shift distances the viewer even more. In previous works, the oblique angles, quick cuts, and suspended narratives made it difficult to find one's grounding, but the handheld camera, and its associations with the French New Wave and cinéma vérité, allow viewers—although never fully in Ruilova's case—to project themselves into the world of the film. In *no no*, and in Ruilova's subsequent works that employ this shift in camera work, the view is emphatically denied that closeness.

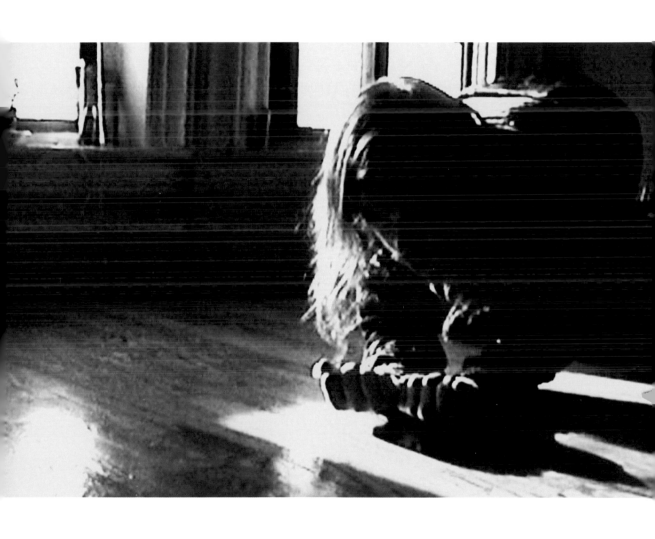

*life like*_2006_5:19

For *life like*, Ruilova returns to the Paris apartment of director Jean Rollin. In one of her longest video works to date, she tempers the truncated, agitated motion of her earlier videos with an extended, ethereal narrative. Here she centers in on her personal fascination with the French horror director, whose erotic vampire films for three decades have gamed on Gothic, decadent morbidity and dark economies of desire. In the dreamlike sequence of *life like*, the camera shuttles between the interior of Rollin's apartment and the exterior locations from his films. Revisiting these sites, blending new footage with Rollin's older scenes, Ruilova traverses the private and filmic spaces of Rollin's macabre world.

Life like opens in Rollin's sunlit apartment, with blinding shafts of light reflecting off the camera's lens. The camera pans across a shelf of books, photographs, wooden clocks, and dolls, intercut at intervals by a pale, young woman's unblinking eye in close-up. Suddenly, the video fires off a string of still shots—misty castle ruins—and the camera returns to the girl's gaze. With heightened sounds of a still room—the girl's breath, her mouth opening and closing, her fingers across bristly skin—the camera then cuts to an image of Jean Rollin's seemingly lifeless body. Below a large, Gothic poster of his seventies' sexploitation film *Fascination* (the same spot shot in Ruilova's earlier *tuning*), the dark-haired girl caresses and clutches the director's stiff, round corpse. Quickly, the camera cuts to a beach, where Ruilova has intercut scenes from Rollin's films with new shots of the girl meandering across the pebbled shore. As the work progresses, the camera jumps from the Paris apartment, where in rapidly spliced shots, the girl strokes Rollin's face and writhes above him, to scenes from Rollin's films, where bewitched beauties haunt cemeteries and grand halls. Punctuating the present-day action—from the girl's alternating grimaces, sobs, and necrophilic advances—Rollin's nubile vampiresses drift through rocky beaches, crumbling châteaux, and overgrown cemeteries. As the feedback between Ruilova's and Rollin's images intensifies, the line between the mediums of his film and her video begin to blur.

For Ruilova, *life like* at once offers homage to Rollin's cinematic oeuvre, and yet works to reverse the ritualized relationship of mentor to her protégé, director to his subject. From their first collaboration in Ruilova's *tuning* (2002), Ruilova and Rollin began to exchange letters, which became, as Ruilova has remarked, increasingly transgressive. For *life like*, Ruilova sought to explore her long affair with the elder auteur's oeuvre, while working to place Rollin and his work within her own filmic frame. Offering both man and work as objects of desire, of study, and of fascination, Ruilova inverts the roles played by both the fetish object and the penetrating male gaze of her patriarch, so omnipresent in his classic films.

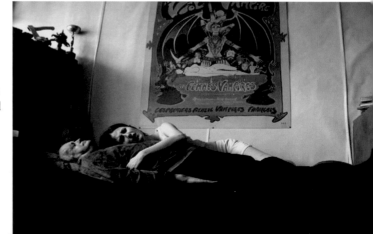

*Lulu*_2007_4:25

A pair of folded hands. A man dangling from a staircase. A close-up of another young man in a suit, crying. A third man, in a dark, nineteenth-century interior, kneeling next to a large, white portrait bust. The dangling man leaps to touch a crystal chandelier. The crying man lies in a pool of his own blood. All under the faint humming of a tune that seems familiar and yet difficult to place.

The opening of *Lulu* reveals the most significant break with Ruilova's frenetically low-fi works from the late 1990s. Based on a character that appeared originally in two plays by the German expressionist playwright Frank Wedekind, who reappears in a film by G. W. Pabst and an opera by Alban Berg, Lulu is an identity-shifting femme fatale who changes to embody the desires of the men who fall in love with her, only later to kill them and ultimately herself. In Ruilova's work, Lulu is played by three men, each who explores a type of male vulnerability. Sometimes alone, sometimes together, they spit in each other's face, stroke one another's cheek, and bludgeon each other with the large portrait bust. The bust becomes a totemic object in the film and like many of the props in Ruilova's other works, is alternately caressed and defiled.

As in one shot where we see overlays of all three men peering into a mirror, it is difficult to discern beginning from end. One of the men sings the Pink Floyd song "Bike" as if it were a lullaby, contrasting sharply with the imagery of seduction and death. In the song, a man shows a girl his borrowed bike and other objects, all in a coded plea to take her into the musical room at the end of the song.

These alternating scenes of violence and tenderness, laughing and crying, and adoration and debasement, all revel in the very oppositions that are at the heart of the character Lulu, amplified here in the switch of gender.

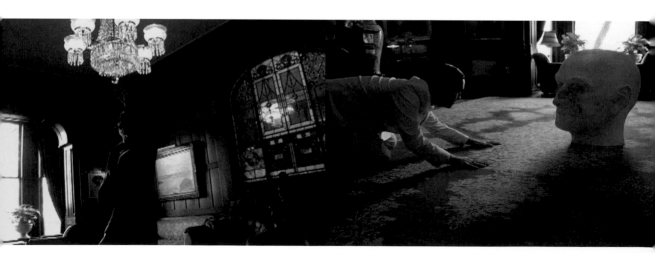

Terrain Vague

———————————————————————————————————

Artist's source material for *life like* and *Lulu*.

The last Wagon

A quickly tale made between the beginning and the end of Friday the 30th of January 2004, with Aida in my brain. Exactly in one hour: 1 PM to 2 PM.

A moving train has always be, for me, a symbol of a vanishing love. a love for somebody who d'ont exist really. a creation for me.

I was in such a train, one finishing day of winter. It was cold outside, and I could see by the glass of the last wagon in witch I was, the rails, the empty rails, running after me. Running without moving. If I can say that.

I walk in the wagon, looking in the compartment. All was empty - Only in the one of the middle was my bag and a big, hot coat.

My coat was moving, like if somebody was hidding under it...

In a hurry, I take off the coat to what was moving.

It was a face. Just a face. Smiling. a girl, so cute, so pure, but with a strange smile on it. Yes, the face was pure, but the smile had something strange, bizarre. Like an invitation. A provocation also. Then, face, smile, sensual provocation, all that disappear. Nothing stay of what I saw.

his bottom, so pure too, so slowy moving, that for a moment nothing else was existing.

I broke the door of this last wagon. Was she still alive? the head of the girl move sloly, and I saw for the second time that smile on his pure face- that smile disturb me, because it was full of perversity. It's look like the vice itself. How she can be at the same time so pure and so vicious?

Always taking my sex in my hand, I jump on the railroad. And I go to her. But in the same time, another train, probably following my train, aproch the no moving body of the girl I was beginning to love.

I was very close to her when the coming train hurt and crashed her. With an horrible noise of broken bones and red blood all around, on me too.

I just jump on the side to let the killing train go his way. And what I saw on the rails was too horrible to be decribe.

But one thing was unchanged: the head with the smile, cut, alone on the rail.

Becoming mad, I felled on my knees, and move my sex to the open mouth of the head. I can't say more. But, from that moment, I take all the trains I can, in the hope to find her again under my coat.

Jean Rollin

The famous Midi Minuit cinema in Paris, showing Rollin's REQUIEM POUR UN VAMPIRE under its alternative title.

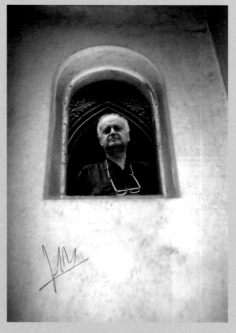

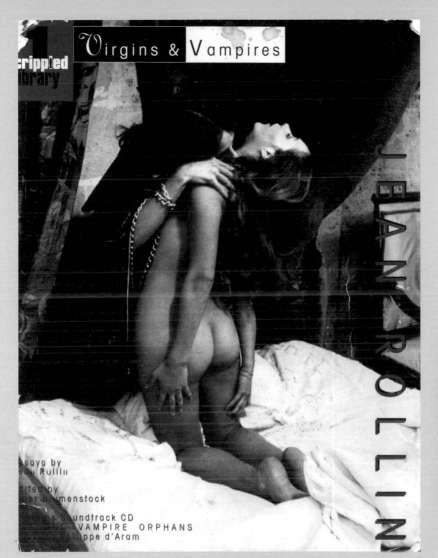

Virgins & Vampires

Crippled Library

JEAN ROLLIN

Essays by
Jean Rollin

Edited by
Peter Blumenstock

Virgins Soundtrack CD
VAMPIRE ORPHANS
Philippe d'Aram

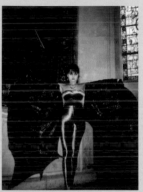

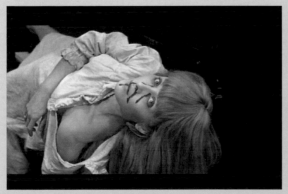

Georges Bataille was living with my mom at the time

It was their communion

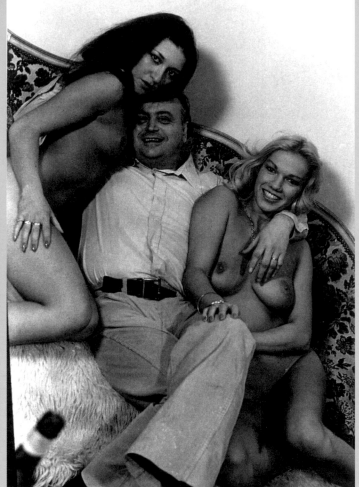

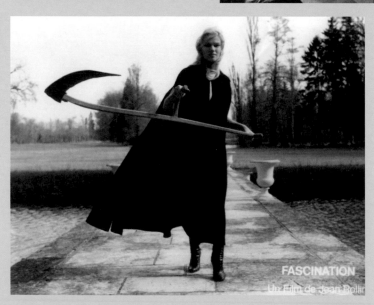

FASCINATION
Un Film de Jean Rollin

Shooting
probably in
June or September.
I hope you can
read my bad
English.
Love and Love again
J. R.

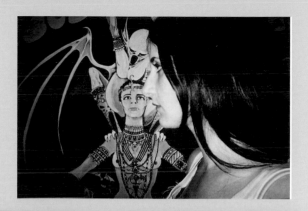

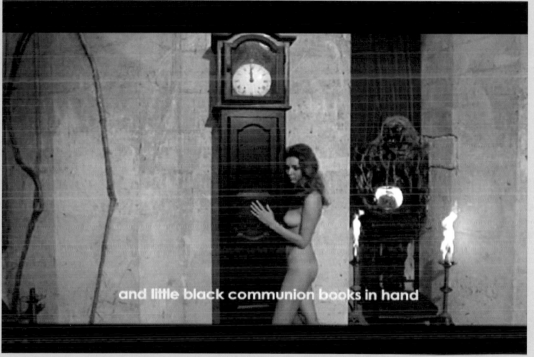

and little black communion books in hand

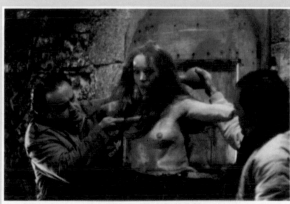

Jean Rollin testing the make-up effect by Alfredo Tibéri (right).

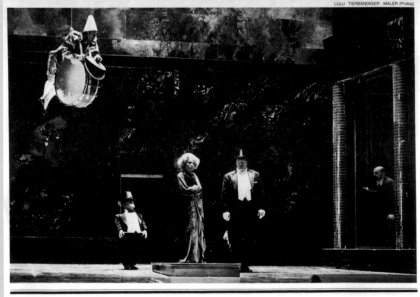

3

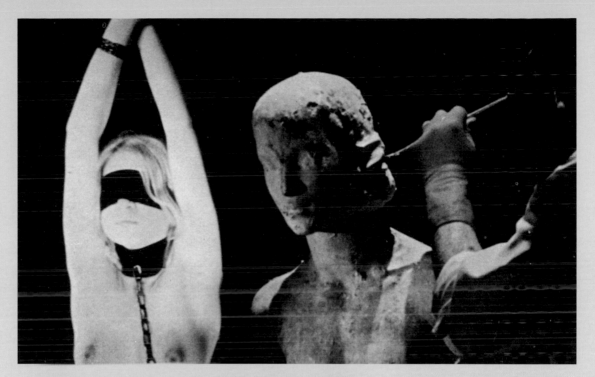

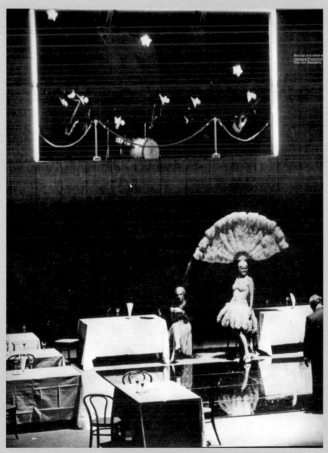

Berg
LULU

Making Time

Matthew Thompson

"The time that pulsates through the blood vessels of the film, making it alive, is of varying rhythmic pressure."

—Andrei Tarkovsky, *Sculpting in Time: Reflections on the Cinema*, 1987

IS THE FILM IMAGE, IN AND OF ITSELF, ALIVE, AS TARKOVSKY SUGGESTS? For Tarkovsky, time is the irreducible foundation of film, rhythm its visible formation. Not the edited sequence of shots but something internal, a time thrust, a pressure. Tarkovsky discusses film in physical terms, and his visceral language implies a medium motivated by an internal force, images joining together according to an innate pattern, a will to coherence.

Compressing and expanding in fits and starts, like harried breathing, time in Ruilova's works is acutely felt. It is both subject and object, written into the sleeping bodies, the chaotic respirations, the light and darkness, drawn out from the ebb and flow of image and expectation. With the rhythm of the film image, Ruilova upsets the body's internal clock, the natural rhythm felt and understood by the viewer.

It is difficult to write about her work without using such terms as *frenetic, fever-pitched, anxiety*—all emotional and physical states that rely upon a relationship with time to achieve meaning. Laid before the viewer, the psychological is physically manifest. This is not the time of this world, at least not the external world of human relationships, but an internal time, wrenched out and channeled through automatons. Try to grasp it and it slips away, as nineteen or thirty-two or fifty-eight seconds at once achieve physicality a true sculpting in time—and then dissolve and loop again. Even sound, a dominant thread, is treated physically, at times achieving mass, becoming sharp, dull, scratching, and then—hush.

The works are impressionistic, with affect at their core. It lies between thought and action, striking from the shadows of the mind. It is the instinctual response, the human, emotional equivalent of Tarkovsky's self-organizing structure that wills a film into existence. In Ruilova's work, affect exists in an inverse relationship between performer and viewer, on one hand reduced, flat, like a shell, recalling the trance of the undead, on the other provoking a complex physical and emotional response, a heightened awareness of self. For Edmund Husserl, the philosophical progenitor of phenomenology, it is time and its effects that separate the real—what is subject to time—from the unreal, which is eternal and atemporal. The interplay between affect and time, the way one conditions and propels the other, pulsates through the blood vessels of Ruilova's work.

Beyond the essential, the irreducible, the sense of time reveals the individuality of the artist. For Tarkovsky, the filmmakers Antonioni, Bergman, Bresson, and Kurasawa are distinguishable—indeed, immediately recognizable—because their perception of time is so remarkably idiosyncratic. And so, too, for Ruilova. She makes time, her rhythm sharp, with an unyielding clarity, felt in a way so utterly distinct.

Exhibition Checklist

All works courtesy of the artist and
Salon 94, New York.

Oh no, 1999

Single-channel video with sound, 00:00:42,
Edition of 5 + 2 artist proofs

Hey, 1999

Single-channel video with sound, 00:00:30,
Edition of 5 + 2 artist proofs

You're pretty, 1999

Single-channel video with sound, 00:00:36,
Edition of 5 + 2 artist proofs

Beat & Perv, 1999

Single-channel video with sound, 00:01:25,
Edition of 5 + 2 artist proofs

Do it, 1999

Single-channel video with sound, 00:00:31,
Edition of 5 + 2 artist proofs

The stun, 2000

Single-channel video with sound, 00:02:00,
Edition of 5 + 2 artist proofs

tuning, 2001

Single-channel video installation with sound, 00:01:16,
Edition of 3 + 2 artist proofs;
dimensions vary with installation

Come here, 2002

Single-channel video with sound, 00:00:29,
Edition of 5 + 2 artist proofs

I have to stop, 2002

Single-channel video with sound, 00:00:33,
Edition of 5 + 2 artist proofs

Almost, 2002

Single-channel video with sound, 00:00:19,
Edition of 5 + 2 artist proofs

3,2,1, I love you, 2002

Single-channel video with sound, 00:00:14,
Edition of 5 + 2 artist proofs

Untitled, 2002

Single-channel video installation with sound, 00:00:58,
Edition of 3 + 2 artist proofs;
dimensions vary with installation

Commissioned by Artpace, San Antonio

Untitled, 2003

Single-channel video installation with sound, 00:00:58,
Edition of 3 + 2 artist proofs;
dimensions vary with installation

Commissioned by Artpace, San Antonio

It had no feelings, 2003

Single-channel video installation with sound, 00:00:21,
Edition of 3 + 2 artist proofs;
dimensions vary with installation

no no, 2004

Single-channel video with sound, 00:00:13,
Edition of 5 + 2 artist proofs

life like, 2006

Single-channel video installation with sound, 00:05:19,
Edition of 3 + 2 artist proofs;
dimensions vary with installation

Featuring Tamaryn Brown and Jean Rollin, with boom
sound by Vincent Tulli; camera assistance by Ian Vanek,
locations by Corinne Borgnet; and translation by Fabienne
Stephan. Excerpts from Jean Rollin's films courtesy
Jean Rollin and ABC FILMS, Paris France: *The Rape of
the Vampire* (1968); *The Nude Vampire* (1969); *The
Shiver of the Vampires* (1970); *The Iron Rose* (1972);
The Demoniacs (1973); *Lips of Blood* (1974); *Grapes
of Death* (1978); *Fascination* (1979); *The Night of the
Hunted* (1980); and *The Living Dead Girl* (1982).

Lulu, 2007

Single-channel video installation with sound, 00:04:25,
Edition of 3 + 2 artist proofs;
dimensions vary with installation

Featuring Dan Burkharth, Adam Dugas, and Thomas
Zipp, with boom sound by Dennis Haggerty; hair and
make-up by Daedra Kaehler; effects by Waldo Warshaw;
assistance by Ian Vanek; and production assistance by
Nancy Garcia and Sam Parker. Produced by Natalie Bitnar.
Special thanks to the National Arts Club and Nye House.

Exhibition History

AÏDA RUILOVA
Born 1974 in Wheeling, West Virginia
Lives and works in New York

EDUCATION

2001 Master of Fine Arts, School of Visual Arts,
 New York

1999 Bachelor of Fine Arts, University of South
 Florida

SELECTED SOLO EXHIBITIONS

2007 *Aïda Ruilova: The Silver Globe*, The Kitchen,
 New York, November 16 – 7.

2005 *Aïda Ruilova: Endings*, Franklin Art Works,
 Minneapolis, April 9 – May 28.

2004 *Let's Go: New Videos*, The Moore Space,
 Miami, September 9 – November 1.

2003 *Untitled*, Center for Curatorial Studies, Bard
 College, Annandale-on-Hudson, New York,
 June 29 – September 27.

2000 *White Room: Aïda Ruilova*, White Columns,
 New York, September 8 – October 15.

SELECTED GROUP EXHIBITIONS

2008 *Slightly Unbalanced* (an iCI exhibition),
 Chicago Cultural Center, January 26 – April 13.

2007 *Exhibitionism: An Exhibition of Exhibitions
 of Works from the Marieluise Hessel
 Collection*, Bard Hessel Museum, Bard
 College, Annandale-on-Hudson, New York,
 October 20, 2007 – February 17, 2008.

 *Sympathy for the Devil: Art and Rock and
 Roll Since 1967*, Museum of Contemporary
 Art, Chicago, September 29, 2007 –
 January 6, 2008.

 Pensée Sauvage On Freedom, Ursula
 Blickle Stiftung, Karlsruhe and Frankfurter
 Kunstverein, Frankfurt, May 20 – July 1.

 Zwischen Zwei Toden/Between Two Deaths,
 ZKM | Center for Art and Media, Karlsruhe,
 Germany, May 12 – August 19.

 Köln Show 2, European Kunsthalle,
 Cologne, Germany, April 19 – May 26.

 *Footnotes on Geopolitics, Markets, and
 Amnesia:* 2nd Moscow Biennale of
 Contemporary Art, Moscow, March 1 – April 1.

 Pale Carnage, Arnolfini, Bristol, England,
 February 17 – April 15; Dundee
 Contemporary Art Center, Dundee, Ireland,
 July 6 – September 20.

2006 *Six Feet Under: Autopsy of Our Relation
 to the Dead*, Kunstmuseum Bern, Switzerland,
 November 2, 2006 – January 21, 2007.

 Protections: This Is Not an Exhibition,
 Kunsthaus Graz, Austria, September
 23 – October 22.

Into Me / Out of Me, P.S.1 Contemporary
Art Center, Long Island City, New York,
June 25 – September 25.

Of Mice and Men: The 4th Berlin Biennal for
Contemporary Art, Berlin, March 25 –
June 5.

Mixed Emotions, Haifa Museum of Art,
Haifa, Israel, February 18 – June 4.

2005 *T1: The Pantagruel Syndrome*,
 Torino Triennale Tremusei, Torino, Italy,
 November 11, 2005 – March 19, 2006

 Uncertain States of America, Astrup Fearnley
 Museet for Moderne Kunst, Oslo, Norway,
 August 10 – November 12.

 Greater New York 2005, P.S.1
 Contemporary Art Center, Long Island City,
 New York, March 13 – September 26.

 *Irreducible: Contemporary Short Form
 Video*, CCA Wattis Institute for
 Contemporary Arts, San Francisco,
 January 19 – March 19.

2004 *Me, Myself & I*, Schmidt Center Gallery,
 Florida Atlantic University, Boca Raton,
 Florida, November 5, 2004 – January 29,
 2005.

 Possessed, Western Bridge, Seattle,
 Washington, May 27 – October 9.

 2004 Whitney Biennial, Whitney Museum of
 American Art, New York, March 11 – June 13.

2003 *Unplugged*, Galleria Civica di Arte
 Contemporanea, Trento, Italy, November
 23, 2003 – February 8, 2004.

 Strange Days, Museum of Contemporary
 Art, Chicago, September 20, 2003 – July 4,
 2004.

 Peripheries Become the Center: Prague
 Biennale 1, National Gallery/Veletržni Palace,
 Prague, Czech Republic, June 26 – August 24.

 Clandestine, 50th Venice Biennale,
 Venice, Italy, June 15 – November 2.

2002 *Videodrome II*, New Museum of
 Contemporary Art, New York, October 2 –
 November 3.

2001 *CASINO 2001:* 1st Quadriënnale, Stedelijk
 Museum voor Actuele Kunst (S.M.A.K), Ghent,
 Belgium, October 28, 2001 – January 13,
 2002.

 Special Projects: Aïda Ruilova, P.S.1
 Contemporary Art Center, Long Island City,
 New York, May 20 – September 20.

2000 *Collectors Choice*, Exit Art, New York,
 November 10, 2000 – January 6, 2001.

Bibliography

SELECTED EXHIBITION CATALOGUES AND BROCHURES

Blumenstein, Ellen and Felix Ensslin, eds. *Zwischen Zwei Toden/Between Two Deaths*. Exhibition catalog. Ostfildern-Ruit: Hatje Cantz, 2007.

Bonami, Francesco. *Aïda Ruilova: New Works: 02.3.* Exhibition brochure. Artpace: San Antonio, 2002.

————. *Dreams and Conflicts: The Dictatorship of the Viewer: the 50th Venice Biennale*. Exh. cat. Venice: Marsilio/Biennale di Venezia, 2003.

Cattelan, Maurizio, Massimiliano Gioni, and Ali Subotnik. *Of Mice and Men: the 4th Berlin Biennial for Contemporary Art*. Exh. cat. Ostfildern-Ruit: Hatje Cantz Verlag, 2006

Hapgood, Susan, ed. *Slightly Unbalanced*. Exh. cat. New York: Independent Curators International (iCI), 2008.

Horowitz, Noah and Brian Sholis, eds. *The Uncertain States of America Reader*. Exh. cat. New York: Sternberg Press; Oslo: the Astrup Fearnley Museum of Modern Art; and London: the Serpentine Gallery, 2006.

Iles, Chrissie, Shamim M. Momin, and Debra Singer. *Whitney Biennial 2004*. Exh. cat. New York: Whitney Museum of American Art, 2004.

Molok, Nikolai, ed. *The 2nd Moscow Biennale of Contemporary Art: Footnotes on Geopolitics, Market, and Amnesia*. Exh. cat. Moscow: Moscow Biennale Art Foundation, 2007.

Molon, Dominic. *Sympathy for the Devil: Art and Rock and Roll Since 1967*. Exh. cat. Chicago: Museum of Contemporary Art Chicago, 2007.

Pace, Linda. *Dreaming in Red: Creating Artpace*. San Antonio: Artpace, a Foundation for Contemporary Art, 2003.

Six Feet Under: Autopsy of our Relation to the Dead. Exh. cat. Bern: Kunstmuseum Bern, 2006.

Young, Joan. "Hey...Um...Uh Oh...: The Video Works of Aïda Ruilova," in the *Hugo Boss Guggenheim Prize*. Exh. cat. Ostfildern-Ruit: Hatje Cantz Verlag; New York: the Solomon R. Guggenheim Museum, 2006.

SELECTED ARTICLES AND REVIEWS

Boucher, Brian. "Aïda Ruilova at Greenberg Van Doren." *Art in America* 93, no. 9 (October 2005): 173.

Cascade, Rebecca. "Making a Scene." *Elle* 20, no. 9 (May 2005): 122.

Charlesworth, J.J. "Review: Casino 2001." *Art Monthly*, no. 252 (December 2001 – January 2002): 33.

Chivaratanond, Sylvia. "Ouverture: Aïda Ruilova." *Flash Art International* 34, no. 219 (July – September, 2001): 114.

Chu, Ingrid. "Aïda Ruilova: and Again...," *Afterall* 13 (spring – summer 2006): 72 – 80.

Cohen, Michael. "The New Gothic: Scary Monsters and Super Creeps." *Flash Art International* 36, no. 231 (July – September, 2003): 108 – 110.

Connor, Michael. "Berlin: art, technology, mice and men." *Real Time* 73 (June – July, 2006). http://www.realtimearts.net/article/issue73/8114.

Cotter, Holland. "Duck! Its the Whitney Biennial Season Again." *The New York Times*, March 7, 2004, 2.28.

————. "An Upbeat Moment for a Downtrodden Area." *The New York Times*, December 1, 2007, B7.

"Don't Miss!" *Time Out New York* (May 5 – 11, 2005): 74.

Kelsey, John. "Review: Come to Life." *Time Out New York* (December 26, 2002 – January 2, 2003): 53.

Kimmelman, Michael. "Youth and the Market: Love at First Sight." *The New York Times*, March 18, 2005, E2:37.

Knight, Christopher. "On the Underbelly of the Zeitgeist." *Los Angeles Times*, February 21, 2003, E24.

Kourlas, Gia. "And All That Jazz..." *Time Out New York* 633 (November 15, 2007): 105.

La Rocco, Claudia. "As Conceptual Art Evolves, One Mission Is Unchanged: Keep Expanding the Possibilities." *New York Times*, November 22, 2007, E5.

Lee, Pamela M. "Many Happy Returns: The 2004 Whitney Biennial (Crystal Lite)." *Artforum* 42 no. 9 (May 2004): 174 – 5.

Mendelsohn, Adam. "Let's Go." *Art Review* 3, no. 7 (July 2005): 109.

———. "Special Focus: Reviews Marathon, New York." *Art Review* 19 (February 2007): 67.

Moreno, Gean. "Aïda Ruilova." *Contemporary Magazine* 78 (February 2006): 44 – 45.

Rosenberg, Karen. "Biennial Favorites: Aïda Ruilova, the Cult Classicist." *New York* 37, no. 7 (March 1, 2004): 36 – 41.

———. "Outside and In." *The Village Voice*, January 15 – 21, 2003, 69.

Saltz, Jerry. "Babylon Rising." *The Village Voice*, September 10 – 16, 2003, 97.

———. "The OK Corral." *The Village Voice*, March 17 – 23, 2004, 80.

Schambelan, Elizabeth. "Critic's Picks," *Artforum.com* (December 9, 2002). http://artforum.com/archive/id=3896&search=ruilova.

Schwabsky, Barry. "Aïda Ruilova: White Columns." *Artforum* 39, no. 4 (December 2000): 148.

———. "Vampire Video: Time in the Art of Aïda Ruilova." *Afterall* 13 (spring – summer 2006): 65 – 71.

Scott, Andrea. "Local Heroes." *Time Out New York* 496 (March 31 – April 6, 2005): 62.

Shariatmadari, David. "Pale Carnage." *Art Review*, no. 11 (May 2007): 131.

Smith, Roberta. "The Art and Artists of the Year: Auspicious Debuts." *The New York Times*, December 28, 2003, 2:37.

———. "Art That Speaks to You. Literally." *The New York Times*, March 7, 2004, 2:30.

———. "Berlin's Biennial Brings New Scene to an Old City." *New York Times*, May 7, 2006, B10.

———. "A Bread-Crumb Trail to the Spirit of the Times." *The New York Times*, January 17, 2003, E2:41.

Sundell, Margaret. "The Today Show." *Time Out New York* 443 (March 25 – April 1, 2004): 56 – 7.

Watson, Simon. "Post Bubble." *Issue* 7 (Fall 2003): 131.

Weyland, Jocko. "American Splendor." *Time Out New York* 440 (March 4 – 11, 2004): 15.

Wilson, Michael. "I, Assassin: Wallspace, New York." *Frieze Magazine* 83 (May 2004).

Artist Acknowledgments

I would like to thank my family and friends for all their support. I would also like to thank my husband, Julian.

A very special thanks to those who have supported me and helped make this show and catalog happen: Jeanne Greenberg-Rohatyn, Guido W. Baudach, Francesca Kaufmann, Chiara Repetto, Fabienne Stephan, Paul Ha, and Heidi Zuckerman Jacobson.

Aïda Ruilova

Image Credits

Film stills

Pages 4 – 5, *Oh no*, 1999–2000; **6 – 7**, *Hey*, 1999;
8 – 9, *You're pretty*, 1999; **10 – 11**, *Beat & Perv*,
1999; **12 – 13**, *Do it*, 1999; **14 – 15**, *The stun*, 2000;
16 – 17, *tuning*, 2001; **18 – 19**, *Come here*, 2002;
20 – 21, *I have to stop*, 2002; **22 – 23**, *Almost*, 2002;
24 – 25, *3,2,1, I love you*, 2002; **26 – 27**, Untitled,
2002; **28 – 29**, Untitled, 2003; **30 – 31**, *It had no
feelings*, 2003; **32 – 33**, *no no*, 2004; **34 – 35**, *life
like*, 2006; **36 – 37**, *Lulu*, 2007.

Terrain Vague

Page 94, clockwise from top left: Letter from Jean Rollin
to Aïda Ruilova; Portrait of Jean Rollin in *Virgins &
Vampires*, ed. Peter Blumenstock (Germany: Crippled
Dick Hot Wax, 1997); Selma Hayek in Aïda Ruilova's
studio; Page from *Virgins & Vampires*.

Page 95, clockwise from top left: Cover of *Virgins &
Vampires*; Production photo, sent to Ruilova by Rollin;
The Nude Vampire [still] (dir. Jean Rollin, 1969, France),
courtesy of Jean Rollin and ABC FILMS; *The Demoniacs*
[still] (dir. Jean Rollin, 1973, France), courtesy of Jean
Rollin and ABC FILMS.

Page 96, clockwise from top left: *Requiem for a Vampire*
[still] (dir. Jean Rollin, 1971, France), courtesy of Jean
Rollin and ABC FILMS; Jean Rollin with Brigitte Lahaie;
Letter from Jean Rollin; Promotional photograph for
Fascination (dir. Jean Rollin, 1979, France), courtesy of
Jean Rollin and ABC FILMS; *The Nude Vampire* [still].

Page 97, clockwise from top left: Tamaryn Brown on the
set of *life like*. Photo by Ian Vanek; *The Shiver of the
Vampires* [still] (dir. Jean Rollin, 1970, France), courtesy
of Jean Rollin and ABC FILMS; Cover of *Immoral Tales:
European Sex and Horror Movies 1956-1984* by Cathal
Tohill and Pete Tombs (New York: St. Martin's Griffin,
1995); *Grapes of Death* [still] (dir. Jean Rollin, 1970,
France), courtesy of Jean Rollin and ABC FILMS;.

Page 98, clockwise from top left: Anja Silja as Lulu from
the vinyl LP, *Lulu*, 1976, Decca Records. Performed
by the Vienna Philharmonic Orchestra, Vienna, photo
by Gert von Bassewitz; Film poster of Lulu by Walerian
Borowczyk; Anja Silja as Lulu from the vinyl LP, *Lulu*,
1976, Decca Records.

Page 99, clockwise from top left: *De Mes Amours
Decomposées* by Jacques Zimmer, reproduced in Midi |
Minuit Fantastique, no.22 (1970); Anja Silja as Lulu from
the vinyl LP, *Lulu*, 1976, Decca Records. Anja Silja as
Lulu from the vinyl LP, *Lulu*, 1976, Decca Records.

Staff & Board

Aspen Art Museum

Heidi Zuckerman Jacobson, *Director and Chief Curator*

Karyn Andrade, *Visitor Services Assistant*

Dasa Bausova, *Visitor Services Assistant*

Dale Benson, *Chief Preparator and Facilities Manager*

Grace Brooks, *Campaign Coordinator*

Ellie Closuit, *Membership Assistant*

Dara Coder, *Assistant Director for Finance and Administration*

Nicole Kinsler, *Curatorial Associate*

Lauren Lively, *Executive Assistant to the Director*

Morley McBride, *Education and Public Programs Manager*

Jeff Murcko, *Public Relations and Marketing Manager*

Jared Rippy, *Graphic Designer*

Rachel Rippy, *Graphic Design Assistant*

Christy Sauer, *Assistant Development Director*

John-Paul Schaefer, *Development Director*

Dorie Shellenbergar, *Visitor Services Coordinator*

Pam Taylor, *Registrar and Exhibitions Manager*

Matthew Thompson, *Assistant Curator*

Wendy Wilhelm, *Special Events Assistant*

Karl Wolfgang, *Staff Photographer*

Contemporary Art Museum St. Louis

Paul Ha, *Director*

Lisa Grove, *Deputy Director and Director of Development*

Kathryn Adamchick, *Director of Education*

Shannon Bailey, *Manager of Institutional Giving*

Bruce Burton, *Graphic Designer*

Laura Fried, *Assistant Curator*

Jennifer Gaby, *Director of Public Relations and Marketing*

Erinn Gavaghan, *Manager of Donor Relations and Special Events*

Anthony Huberman, *Chief Curator*

Jason Miller, *Facilities Manager/Assistant Preparator*

Maria Quinlan, *Projects Assistant*

Cole Root, *Registrar and Event Operations Manager*

Ben Shepard, *Art Instructor*

Shane Simmons, *Exhibition and Operations Manager*

Kiersten Torrez, *Visitor Services and Retail Operations Coordinator*

Mary Walters, *Director of Finance and Administration*

Contemporary Art Museum St. Louis

This publication accompanies
Aïda Ruilova: The Singles 1999 – Now

Aspen Art Museum (May 29 – August 7, 2008)
Contemporary Art Museum St. Louis (September 12, 2008 – January 4, 2009)
Walter Phillips Gallery, Banff (January 24 – March 15, 2009)
Contemporary Art Center New Orleans (April 11 – July 14, 2009)
Museum of Contemporary Art Cleveland (September 11, 2009 – January 3, 2010)

Published by

Aspen Art Museum
590 North Mill Street, Aspen, Colorado 81611
www.aspenartmuseum.org

&

Contemporary Art Museum St. Louis
3750 Washington Boulevard, St. Louis, Missouri 63108
www.contemporarystl.org

Edition: 2,000

ISBN: 9780977752843

Designed by Bruce Burton
Edited by Gerald Zeigerman/Laura Fried
Typefaces: ITC Souvenir (1970) by Edward Benguiat,
Avenir (1988) by Adrian Frutiger, and Humanist (2005) by Sumner Stone

Printed by Stolze Printing, Inc., St. Louis, Missouri
Bound by BindTech, Inc., Nashville, Tennesse

Distributed by D.A.P. / Distributed Art Publishers
155 Sixth Avenue, 2nd floor
New York, NY 10013
Tel: (212) 627.1999 Fax: (212) 627-9484